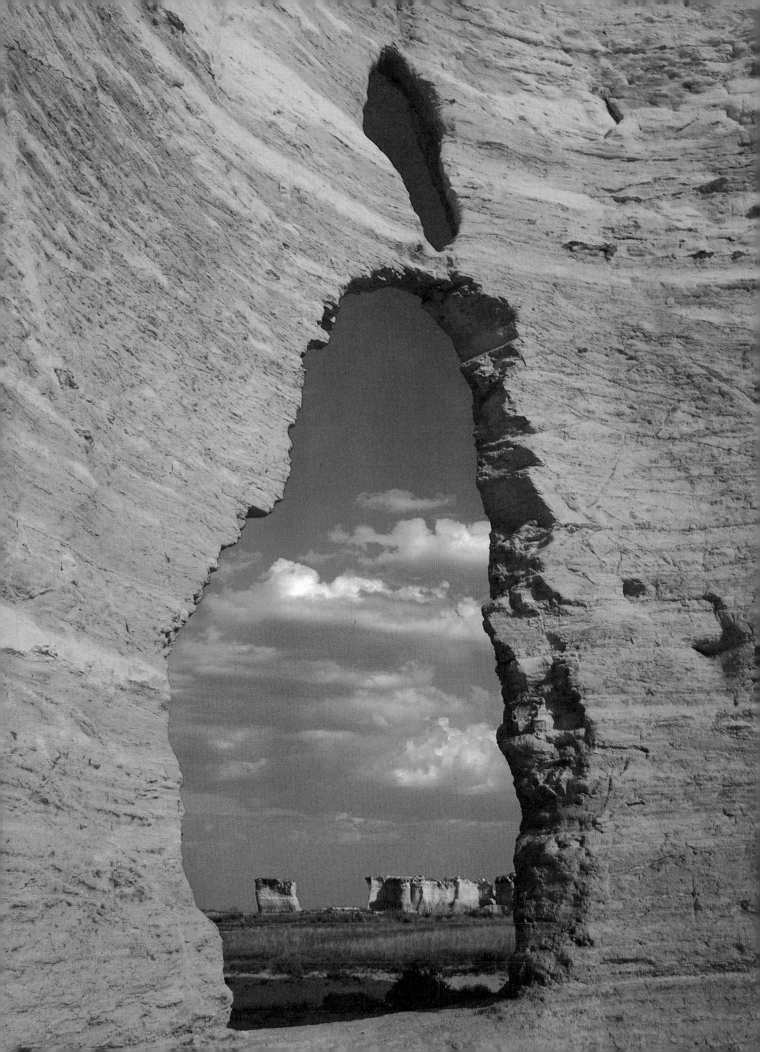

IN COLOR

PHOTOGRAPHS SELECTED BY <u>KANSAS!</u> MAGAZINE

EDITED BY ANDREA GLENN
INTRODUCTION BY ZULA BENNINGTON GREENE

Published for the Kansas Department of Economic Development
by the University Press of Kansas

*P*age 1. Monument Rocks south of Oakley in Gove County.

*P*ages 2–3. Western Kansas sunset.

*P*age 6. Storm above the plains in northwest Kansas.

*P*age 17. Horseback through the Gypsum Hills near Medicine Lodge.

©1982 by the University Press of Kansas
All rights reserved
Published by the University Press of Kansas (Lawrence, Kansas 66045), which was organized by the Kansas Board of Regents and is operated and funded by Emporia State University, Fort Hays State University, Kansas State University, Pittsburg State University, the University of Kansas, and Wichita State University.

LC 82-060564
ISBN 0-7006-0229-1

Printed in the United States of America
Designed by Steven Skaggs

1st printing, 10,000, 1982
2nd printing, 10,000, 1982
3rd printing, 10,000, 1983

PREFACE

THERE is a captivatingly subtle beauty to this state of Kansas that many of us call home. What we may lack in purple mountain majesty, we more than make up for in our amber waves of grain and fruited plain, in our rolling, green Flint Hills, and in our spacious, deep-blue skies. Kansas is many things to many people. It is rich, fertile farmland to the wheat farmer, lush grazing land to the cattle rancher, and miles of reservoir shoreline to the fisherman and vacationer. The beauty to those who know the state best is in the spectacular sunsets over the gently waving wheat and in the horizon that stretches as far as the eye can see.

It is this subtle beauty and the people who live in its midst that have formed the character of the quarterly *Kansas!* Magazine published by the Kansas Department of Economic Development, a state agency, under that title and in full color since 1964. Available by subscription since 1977, the magazine features in each issue articles about Kansas' many interesting people, places, and events. Though it is my belief that there is truly no end to what can be said in photographs and story about this great state, it would never be possible to say it well without the cooperation and aid of the many Kansas writers and photographers with whom I have worked over the past several years. Their tireless efforts have been much appreciated by our many *Kansas!* Magazine readers and myself.

When the Kansas Department of Economic Development and the University Press of Kansas decided that a book of color photographs of Kansas was long overdue, finding a source for the photographs was fairly easy. Making the selection, however, was not. To choose the best 100 photographs to represent Kansas from a collection of approximately 4,000 was indeed an awesome task. But, as we made the selection, we kept in mind our original goal for the book which was quite simply to make the reader feel good about Kansas. It is my hope that the selection within these pages accomplished our goal.

—Andrea Glenn
Editor, *Kansas!*

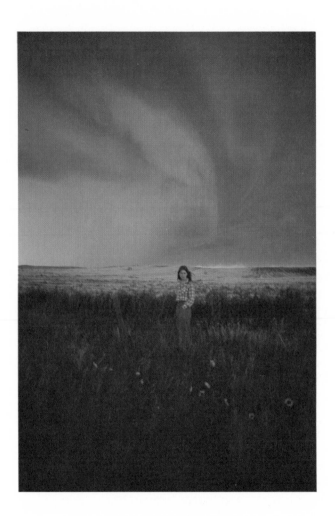

BEFORE I ever came to Kansas, I had been tilted in its favor. My father, who spent his growing-up years in Cherokee County and attended Teachers Institute in Fort Scott, talked about Kansas with the tenderness of a man remembering his first love.

When I married and came with my husband, Willard, to live with his parents on their farm in the Flint Hills, I began discovering it for myself and seeing it through the eyes of my father-in-law, Elisha Barton Greene III. He had brought his family here in the early years of the century because Kansas was a prohibition state and he did not want his children growing up in Ohio, where liquor was sold.

There was another reason. He had always wanted to farm. So, when he was past fifty he disposed of his iron business in Zanesville, Ohio, put his household furnishings on a freight car, and came to Emporia. That town had been chosen because it had a Presbyterian college. He rented a house, put his children in school, and began looking for his land.

When he saw the twelve-room house on a large Chase County farm, he bought it, saying, "That house will hold all my children." He had five sons and three daughters, the youngest being three small boys, my husband the middle one. An orphaned niece and nephew often lived there too.

No native-born Kansan ever loved the state more. He did not complain of heat or cold, flood or drouth, but accepted them as part of nature's plan. He loved the hills rising all around, loved the fresh air, the weather. He would stand at a window to enjoy the drama of a prairie storm, and one time we found him holding our daughter Margaret, not quite two, in his arms; both were as entranced as children by Fourth of July fireworks.

But most of all he loved the land. He thought of himself as the owner of something of great and permanent value, to be used and improved and left in better condition than he found it. When a neighbor, disagreeing with his conservation of timber, said, "There'll be trees here when you're gone," father answered, "And people to need them." When land was being leased for oil, he said, "I'd rather they found a good well of water."

He would draw a fresh bucket of water from the well, take a long drink, and say with deep contentment, "Best water I ever tasted." All the rest of his life he lived on his land, refusing to

go to his daughters in their city homes even when he was old and ill, when the house had burned and we were living in four rooms instead of twelve, and when depression was stalking the land.

FOR millions of years the forces of nature had been shaping the land that came to be called Kansas. Many times, with nobody there to chronicle its comings and its goings, the sea flowed over the land, building up layers of limestone and shale that held the shapes of creatures of the sea. Eons of time passed while the rocks were forming, and more eons brought upheavals that turned the rocks into cliffs and bluffs and roadside ornaments. Some of it looks like the old stone fences that pioneers built of rocks cleared from their land.

In and around the rock and shale, tucked in like a well-packed Christmas box, were gifts for the people, put there to be discovered when they were needed—coal, oil, gas, sand, gravel, ceramic clay, lead, zinc, salt, stone for building, and pretty little rocks for a child to find in the yard. But most valuable of all the things hidden in the rocks was water, great rivers of underground water that was to be of greater use to the people than surface water.

Into the northeastern corner of the state came the glaciers, mountains of ice, and rolled up in the ice were large boulders of hard red quartzite that were left like calling cards. The glaciers brought silt that flowed over the land as the ice melted and turned it into good corn country. Deep, spectacular bluffs, which formed along the Missouri River where it cuts a corner off the state, have given this part its name, Kansas Switzerland.

Over the land was spread the miracle of grass. Geologists say that in the cold temperatures following the glaciers, forests of pine and spruce covered the plains. As the climate grew warmer, the evergreens were replaced by deciduous trees similar to those now in Kansas. As the rainfall diminished, the trees died and gave way to grass, which has been here for ten thousand years. John J. Ingalls, a scholarly man who came here from Massachusetts, called grass "the forgiveness of nature—her constant benediction."

Kansas links the heartland of the nation with the Rocky Mountains region. The lowest point in the state is Coffeyville, which some precise person has measured at 699 feet above sea level. The highest is Mount Sunflower at 4,025 feet in Wallace County near the Colorado border. From west to east the land usually descends gently, but in a few places the drop is abrupt enough to create rugged scenery and to veer the rivers to the southeast. The vegetation changes as the annual rainfall decreases in the west, which averages about 15 inches versus the 40 inches in the east.

Extending north to south across most of the state, next to the wooded farmlands of the east, is a unique formation, the Flint Hills. It is doubtful, geologists say, that anywhere else can be found

the same kind of rock-terraced hills and gentle valleys. The soil is shallow and flinty, but in it grows the unsurpassed bluestem grass, which fattens cattle on a summer's pasturing. No other grazing—timothy hay, alfalfa, bluegrass—equals bluestem in putting weight on beef.

The Flint Hills have their own scenic beauty. They rise in clean sculptured curves, hill beyond hill, sloping from an outcropping at the top of the curve. In summer they spread out in a mass of green, and in the distance the green turns to misty blue and the misty blue to hazy purple as they bump against the horizon. Sometimes in early morning they are amethyst against a dusky sky, and in the evening with pools of shadows they are dark green velvet and jade. Winding among them, the streams are silver ribbons looped on an emerald gown.

Frost turns the hills into a tawny golden brown, touched with pink and cinnamon, with soft peach and taupe and rust, a color that has no name. Under the warm gold of the sun they look like great rounded sand heaps, where a giant's child might play. Then some winter morning you wake and look out on long slopes of spotless white, on which a few strokes of Spencerian script are scrawled by scattered dark trees in the draws. And at that moment they may seem at their best. My husband and I sometimes watched the full moon as it rose slowly over the farthest rim, looking like a great pale apricot as it set out on its nightly journey across the sky.

The Flint Hills are not the biggest, the highest, the deepest of anything. They are not an oddity like hot water spouting from the ground, a river falling twenty stories, a deep gash in the earth. Crowds of tourists do not gather around them. They are for quiet seeing. Drive through them and you begin to feel their solitude. Occasionally a narrow road curves off around a ledge and disappears. Lean tanned men in old Levis and quilted boots and worn Stetsons ride along the roads, sometimes behind shuffling white-faced cattle. Children who can't remember when they learned to ride gallop to school on spotted cow ponies.

The first settlers learned that bluestem grass, once plowed up, is slow to return, and that the plowed ground is not productive for crops. Then they learned its value as pasture. Cattle were driven from Texas to the pastures, then shipped by rail. Now they come in trucks, permitting the weary travelers to step right out into lush bluestem.

FARTHER west the grass is shorter—buffalo grass and grama, mixed with some desert vegetation. Land that later was to share its bounteous grain with the world was labeled on early maps as the Great American Desert. Major Stephen R. Long of the U.S. Topographical Engineers arrived there in 1819 and reported: "It is

almost wholly unfit for cultivation and of course uninhabitable by a people depending on agriculture for their sustenance."

In 1806 Zebulon Pike surveyed the vast plains, probably in what is now the sand dunes of Hamilton County, because he said, "They may become in time as celebrated as the sandy deserts of Africa." Another of his observations was that the immense prairies might restrict westward migration and thus preserve the Union. "Our citizens being so prone to rambling and extending themselves on the frontier, will," he opined, "through necessity be constrained to limit their extent on the west to the borders of the Missouri and Mississippi, while they leave the prairies, incapable of cultivation, to the wandering and uncivilized aborigines of the country." Mr. Pike's crystal ball may have got fogged up that day.

Ahead of these explorers by some 300 years had come Francisco Vásquez de Coronado, who reached what is now central Kansas and reported on the excellence of the soil. But he made no settlements. He wanted gold he could hold in his hands, not the promise of rich land.

The high plains filled the western land, mile after mile of grass, stretching out endlessly, a vast unfenced prairie with rarely a tree in sight. To an explorer proceeding on horseback—riding day after day, camping night after night, hearing the lonesome cries of the coyote, encountering great herds of buffalo, facing winds and weather, and alert for Indians—the plains must have seemed boundless, perhaps desolate or awesome, and worthless for civilized habitation. They must have been contrasted with the settled farmland and wooded streams back east.

The Indians to the east built permanent houses and grew maize, beans, squash, and other foodstuffs. Wild game was plentiful, and farther west the buffalo was hunted, but was killed only for food and skins and for whatever use could be made of the bones. Indians lived as consumers, selling nothing and taking only what they needed for themselves. They thought of the land and its resources as gifts that belonged to everybody. It was the white man with his guns who slaughtered the buffalo.

An early atlas in McPherson County tells a story about the buffalo. In 1868, when a severe drouth had made water and grass scarce, the animals were often hungry and crazed for water. A herd, described as "thirty miles in length, long enough to extend clear across the county," stampeded to the Smoky Hill River and drank it dry. The first to enter the stream were pushed across and up the opposite bank by others crowding in. Reports were made of herds so large that they darkened the prairie clear to the horizon and of trains stopped for most of a day while a herd crossed the track.

THIS was the land that was to be plowed and planted, fenced and bridged by people who would come—some for a cause, some for a home, some for money and power, some for adventure.

The Kansas-Nebraska Act of 1854 opened the gate. It provided that the slavery question would be settled by the people who lived there. Groups were sent from New England to work for a free state. People came across the line from Missouri to work for slavery, some to stay and make homes, others just to vote.

Sara T. D. Robinson and her husband Charles, who became the first governor of Kansas, came to Lawrence in 1854. Two years later she published a book, *Kansas—Its Interior and Exterior Life,* which had ten printings and has not been surpassed for Kansas fervor. In the same breath she marveled at the view from Mount Oread and denounced man's inhumanity to man. In one sentence she said, "Our food is mush, bacon and molasses plentifully sprinkled with dirt three times a day, a more beautiful country I certainly never saw." Hardships were brushed aside. If the roof leaked, one moved the furniture to the other side of the room. One night when the house was overflowing with company, she slept on skins in the attic and reported a restful sleep, being awakened only a few times by mice nibbling at her fingers. Friends came, bringing her a crock of butter, which she tried to keep all summer by moving it to the shade as the sunlight changed. "How our friends in the east would pity us," she said, "if they knew just how we live, yet I dare say there is not one in a hundred who enjoys the half we do. . . . We have pure fresh air, fine spirits and feel that to live in a land like this is a joy."

Covered wagons began rolling in, and what careful thought must have been given to what should go into them. The recorded contents of one were a wood-burning stove, bedsteads, bedding, cooking utensils, a few pieces of furniture, a muzzle-loading rifle. Fastened on the outside of the wagon were a scythe, a cradle (probably for harvesting wheat rather than for rocking a baby), a breaking plow, a 14-inch stirring plow, 12 crated hens, wooden washtubs, wooden water pails. At the end of the wagon was a feedbox for the horses.

Seeds and plants came in the covered wagons, and fruit trees—peach and cherry and apple—either seedlings set in buckets or with roots carefully bound in soil. The women brought sprouts of lilac. For a good many years homesteads were identified by the old lilac bushes in the yard. Near them were plantings of iris, which were called flags, and old-fashioned red roses.

Soon settlers were pushing into the high plains and planting corn. Most had come from the humid, corn-producing states like Iowa, Ohio, Indiana, and Illinois. Up until 1910 more corn than wheat was planted in western Kansas. When drouth or

grasshoppers caused a crop failure, some settlers were forced to leave. Others, with help from families back east, were able to hold on and plant another crop.

In 1874 German farmers who had gone to Russia a few years earlier came to central Kansas, each family bringing two bushels of Turkey Red wheat. Some time ago an elderly woman in Hillsboro recalled how she was one of the children who selected the wheat, grain by grain, the biggest and the best. Their reward was a handful of hazelnuts. This wheat thrived in Kansas soil and set the stage for the great wheat crops that overflow bins and elevators every year.

Horses were used in Kansas wheat fields until the end of World War I. Then the combine came; it not only "eliminated the vast army of floating harvest hands," but also made possible larger fields. In 1948 Kansas wheat farmers raised 90 percent more wheat per hour of labor than in 1910, when the yield was 15 million bushels. Now a prediction of 400 million bushels or more occasions no surprise.

What a magnificent sight it is, the stunning splendor of a great field of ripened wheat. A restless sea of gold, the heads bend and rise in the wind, flowing like waves of the ocean and rustling like surf. Will the heads bend to the sickle as proudly as a queen going to the guillotine?

This is the time when the owner plucks a few heads to judge the development of starch in the grains and checks the weather. He wants nothing but warm, gentle sunny days—wheat harvest weather. Nobody in his presence mentions the round pellets of ice that can fall from a cloud. The four-letter word is not spoken in that house.

NATURE is not a neat performer. She tosses things about, mislays, mixes together, upheaves, covers, and carries on without plan or pattern, letting happen what will happen. But it may have been a mischievous prank of wind and water—a pair that can be both wild and winsome—that shaped the Gypsum Hills. Also called the Red Hills, they extend along the southern border of the state, west of center, and wander through half a dozen counties.

For uncounted centuries wind and water swept through the clay soil and carved canyons. They tore away layers of silt and shale, leaving rocks that are rugged and spectacular, odd and whimsical. Hell's Half Acre may have been named by an impish mortal. Its ten acres of striking scenery in Comanche County could as well have been called the Garden of the Gods. Or the collection of pulpit rocks might have suggested Parsons' Paradise. A natural bridge near Sun City, which sweeps majestically across a stream twelve feet below, has outlasted all of the London bridges.

In another area, five or six rocks look like delegates

conferring before they go in to vote. One standing off by itself might be a woman who came to the conference alone and doesn't know anybody. A tall angular rock suggests a young teenage boy who is suddenly six feet tall and doesn't know what to do with the extra inches.

From the air the Gypsum Hills must present a beautiful mosaic—bright red sandstone, brown-and-gold-striped limestone, the light green of buffalo grass, the dark greens of cedars, the greens of other trees, dotted with a multitude of bright wild flowers and all worked in needlepoint on a background of gray sagebrush.

I first saw these hills when I was a guest at the Eagle Canyon ranch of Benjamin and Marietta Weaver, who lived near Mullinville. Marietta's father, John Marriage, had come from England to Iowa and was developing his own breed of cattle, a dual-purpose, all red, hornless breed called Marriage Muleys. They outgrew a small farm in Iowa. Hearing good reports from Kansas, he came to Larned in 1898 to have a look at the land. He bought a spade, hired a horse, and scouted for the best farmland in the west. For three months he rode into the adjoining counties, digging deep to find the extent of subsoil moisture and the depth of top loam. Finally, at a place in Kiowa County, near a deep canyon, he stuck his spade into the earth and, like Brigham Young, said, "This is the place."

He and his wife and their two children lived in a big tent for a year while their house was being built. The four-story house was built in the canyon, the two bottom stories facing the canyon, the two top stories opening on the surface. He chose the canyon because it would provide shelter. Cattle grazed on the grass along the sides and in the bottom. Adjoining the canyon were a thousand acres of good wheat land.

Much of the land was obtained just by paying the delinquent taxes, from $50 to $200 a quarter section. One quarter came from a merchant on an even trade for a buggy, harness, and a pair of good driving horses. Houses were built for the cowhands, and 50 range horses were bought for them to break. All the farming was done with six-horse teams. A blacksmith and a carpenter were regularly employed. Marietta said her mother "boarded gangs of men the year round."

Indians called the Gypsum Hills the Medicine Hills, claiming a spirit lived there that could cure sickness and heal sores. The water, which contains calcium and magnesium sulphates and minerals from the gypsum, is not liked by the people; but the animals, perhaps from necessity, drink it. The chemist supports the Indians' claim. The sulphates are the stuff of Epsom salt, which is not only a cathartic, but can also be taken as a tonic, like sulphur and molasses, and used internally and externally.

ONE summer we bought a new washing machine, a square-tub electric Maytag, the kind, we are told, that is so good that its repairmen are half starved. Part of the payment came from money I earned speaking at teachers institutes in western Kansas. I drove with one of the officials, seeing sights along the way and, for the first time, seeing the prairies for days at a time. I am still in love with them.

Rock City, near Minneapolis, is so unusual that in some states it would be surrounded by a high board fence and an admission fee charged. More than 200 large spherical and elliptical rocks lie on the ground, like toys that children have abandoned. Some are 12 feet in diameter; the elliptical ones, twice as wide. Geologists say that in the distant past the surface was higher and these concretions were formed underground. Water carried away the surrounding soil and left them on top, like nothing I have seen anywhere else.

Out of Salina we ran into the beautiful post rocks. With no trees to supply fence posts, the early settlers turned back the sod and took slabs of limestone from the ground, driving spikes into the stone to split it. When first uncovered, the limestone is soft enough to saw, but hardens when exposed. Set in the ground, the posts stand against rust and moth, wind and weather, and time.

At Sharon Springs, where one of the institutes was held, somebody said, "She ought to see the sinks." A sink, I learned, is a cave-in of the earth, where ground water has dissolved and carried away the supports. We drove to the Old Maid's Pool, a large pond 200 feet deep, which has never gone dry. It was known and used by early-day travelers. A more recent sink developed in 1926 when a portion of the ground disappeared, leaving a gap 200 feet across and 500 feet deep. It filled with water from the Smoky Hill River. In 1941 at the intersection of two county roads in Butler County a hole the size of a city block was made. An iron bridge that had covered a drainage point now stands at the bottom of the hole. A sink that is centuries old is St. Jacob's Well in Clark County. Large trees grow on its inner walls.

The Smoky Hill River has carved fanciful scenery from the chalk cliffs along its banks. Gove County has large rock formations that look as though they may have rolled down from the Rocky Mountains and then taken root. One group is called Castle Rock. Another is named the Sphinx, and the Monument Rocks resemble a minor Stonehenge. I wonder if people take boats down the Smoky Hill River to see the scenery.

I did not see White Woman Creek, but long ago a friend gave me his article about it. The creek has always held a hint of mystery. It does not start from any stream, nor does it empty into any stream. It just appears suddenly, wanders a few hundred miles about the country, and as suddenly disappears. It starts in Colorado,

crosses Greeley and Wichita counties, and ends in a great flat basin a few miles south of Scott City. The rumor that it goes underground is denied by people in that area. They say it just stops because it runs out of water.

But the best feature of the prairies is the prairies themselves. They spread out around you, vast and mysterious under the great blue dome of sky. They do not move you suddenly and dramatically, as a turn in a mountain road can do. But mile after mile, through the towns with their castles of grain elevators, they creep into you and fill you with their peace. No sound breaks the stillness but the sweet innocent song of the meadowlark.

And that is how it happened that sometimes when I was running clothes through the Maytag, the prairies came to me, reaching out to touch the sky.

THIS is Star Valley," Gene DeGruson of Pittsburg said. He had brought me a framed color photograph of the countryside with white blossoms and tall grasses. Star Valley—a name I had heard many years ago—was where my father went to school.

It was through Gene that I began to learn something about southeast Kansas. Little Balkans is a name given to that corner of Kansas, some say, in deference to the origin of the immigrants who settled there. Once an ancient bog, the area has rich horizontal veins of coal, not far from the surface, which earlier in the century caused advertisements to be placed in European newspapers for miners to work in Kansas.

The people there call it the Garden Spot of Kansas. It has more trees and rivers and is greener than many other parts of the state. The dark mounds that look like great loaves of pumpernickel bread are residue from the old zinc and copper mines. The old strip pits left from surface coal mining are now filled with water and have been stocked with fish by a state agency. Like the dikes of Holland, they make a pleasant addition to the scenery. They curve about, following the veins of coal sometimes for a quarter of a mile, and look like lakes. My son-in-law, Dick Hanger, says they provide "fantastic fishing." Owners of coal mines are now required to reclaim the land, planting it to grass or leaving it ready for crops.

KANSAS was once a great moving sea of grass crossed by prairie schooners. Some travelers who had lived by the sea, not surprisingly, also thought of sails. In 1860 Samuel Peppard of Oskaloosa made a wagon with two sails to travel to Pike's Peak. In an account of the trip he said his best time was 2 miles in 4 minutes. One day he traveled 50 miles in 3 hours and passed 625 teams. The road was full of people going to Colorado for gold. Eventually a whirlwind lifted the wagon into the air and disabled it.

In Kansas the wind and weather are choice topics of conversation. No less an authority than the 1911 *Encyclopaedia Britannica* declared, "The climate of Kansas is exceptionally salubrious. Extremes of heat and cold occur, but as a rule the winters are dry and mild, while the summer heats are tempered by the perpetual prairie breezes, and the summer nights are usually cool and refreshing." Dissenters are not unknown.

"I never saw a place where there was such violent weather," said a corporal from Anderson, Indiana, who was stationed at Fort Riley during the war. "Such terrible lightning, such awful winds, such a strange-colored sky." He was very young and probably homesick for whatever kind of weather they had in Indiana.

We do have jagged lightning that rips open the sky and is accompanied by Wagnerian thunderbolts. But we also complain when there's too little lightning and thunder, as though the staccato beat of rain cannot satisfy without a prelude that displays elemental force. Contrasts make weather interesting. How could we thrill to a sunshiny spring day, with the honey locusts dripping sweetness, if there had been no winter? And how can a drenching rain bring sighs of contentment unless it follows heat?

Kansans who move to sunny climates miss Kansas weather. My son Willard and his wife Marilyn live in Florida. Sometimes they come in May to see a gentle spring, sometimes in October to see the leaves turn, and sometimes in December— whether for Christmas or the hope of snow is not clear.

One early morning in the 1940s my husband and I were returning home from a trip we had taken, and we overtook a man walking on a country road. He was thin and wiry, dressed in a shirt and faded overalls. We gave him a ride and listened to him talk. One thing he would never do was wear a wristwatch. Two things he wanted to do were to make a speech and to have a poem of his printed in a paper. He did not speak of the hard times he must have had, nor of the hard work, but of the beauty of the morning, of the fresh air and trees, and of the joy of living in the country. In his praise of the day, he gave me a phrase I shall not forget. "A day like this," he said, "is the enamel of life."

Kansans young and old love their state. When she was seven, our daughter Dorothy visited her aunt on a Missouri farm and longed for home before the time appointed to return. As our car crossed the state line and entered Kansas, she sighed, "The air is better already."

—*Zula Bennington Greene*

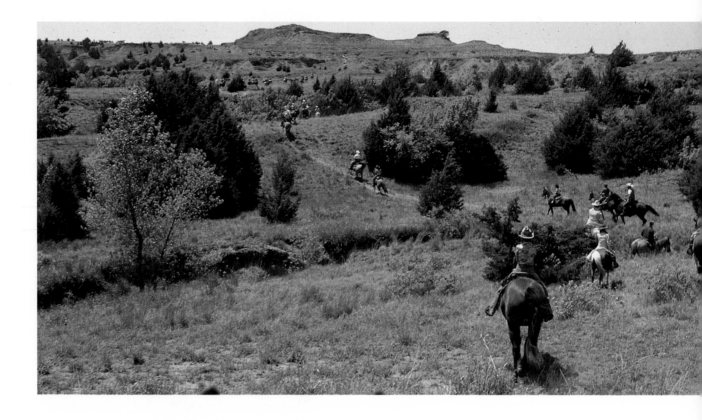

Sun breaks through clouds over the Kansas prairie.

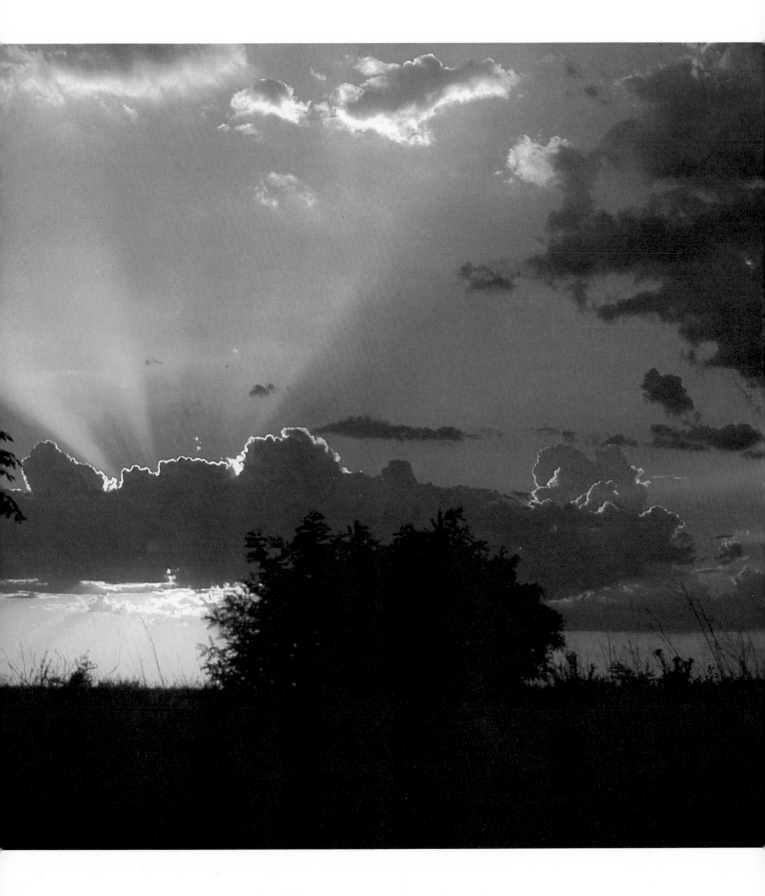

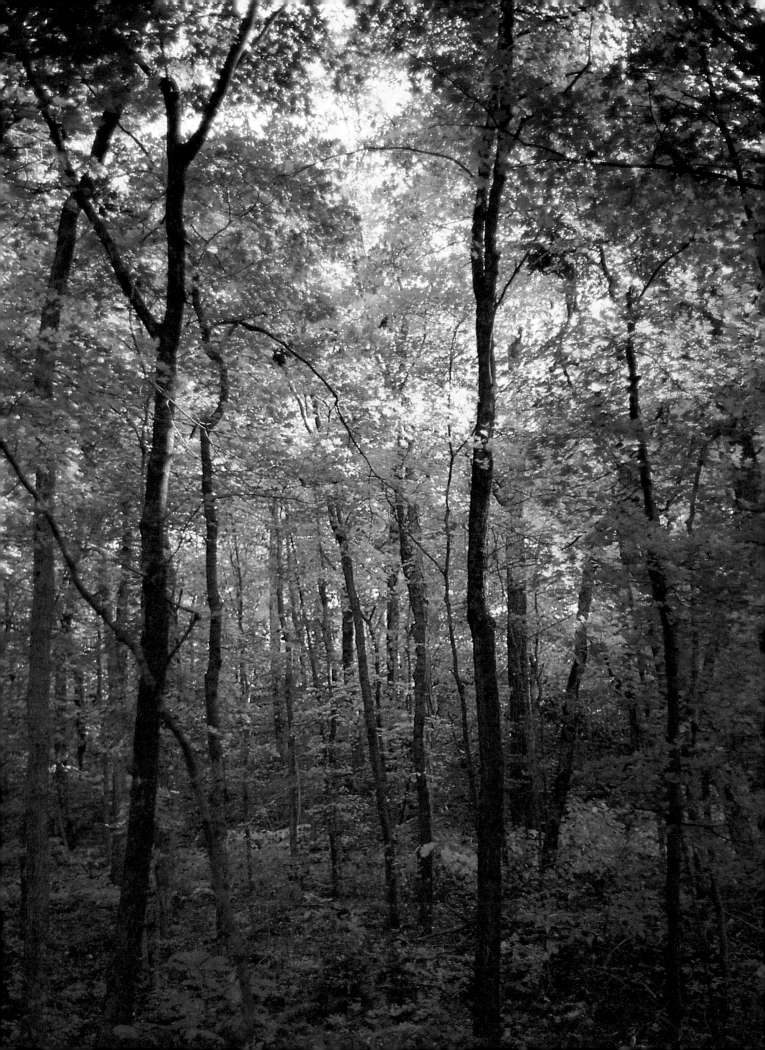

Maple forest in Linn County.

Stone mill along Cottonwood River in Cedar Point, Chase County.

Pages 22–23. Spring in the Smoky Hills in Lincoln County.

Pages 24–25. Fall leaves add color to this dense thicket in northeast Kansas.

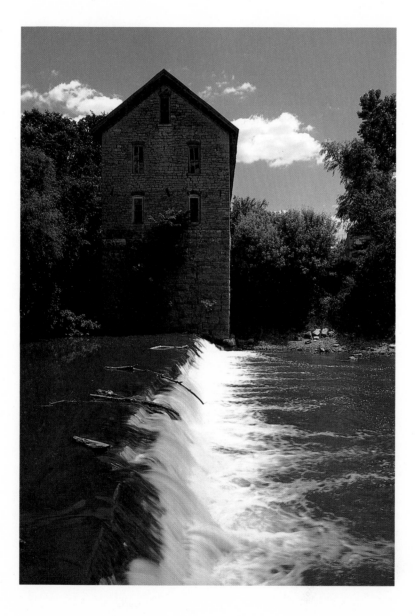

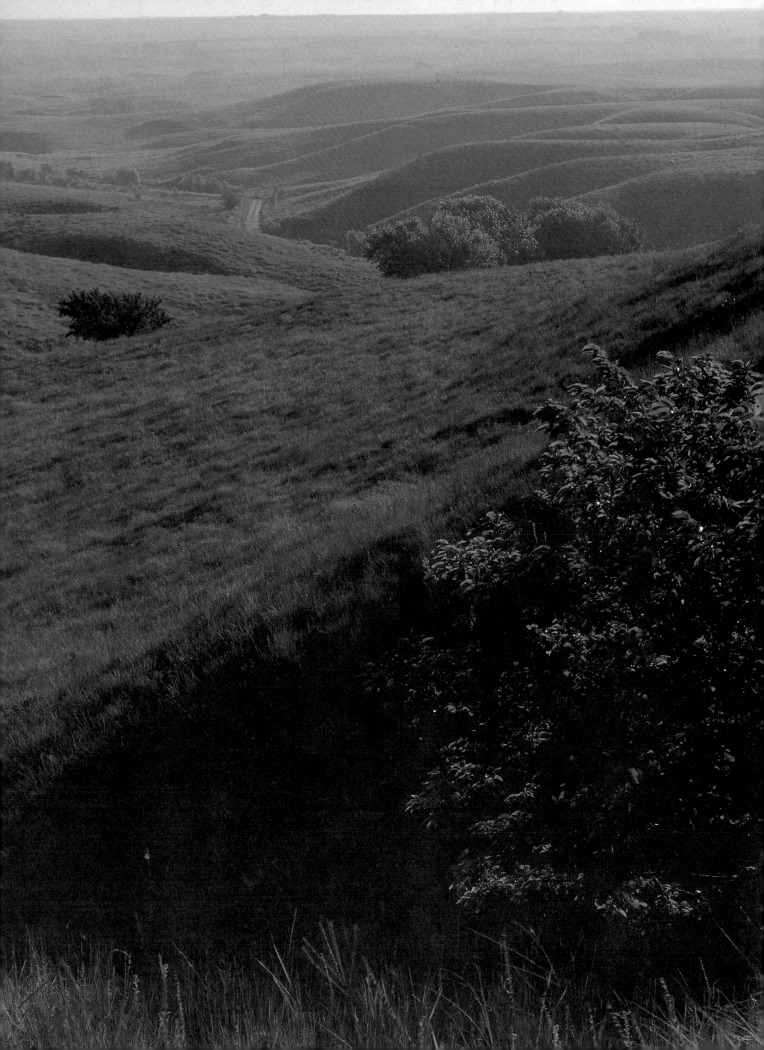

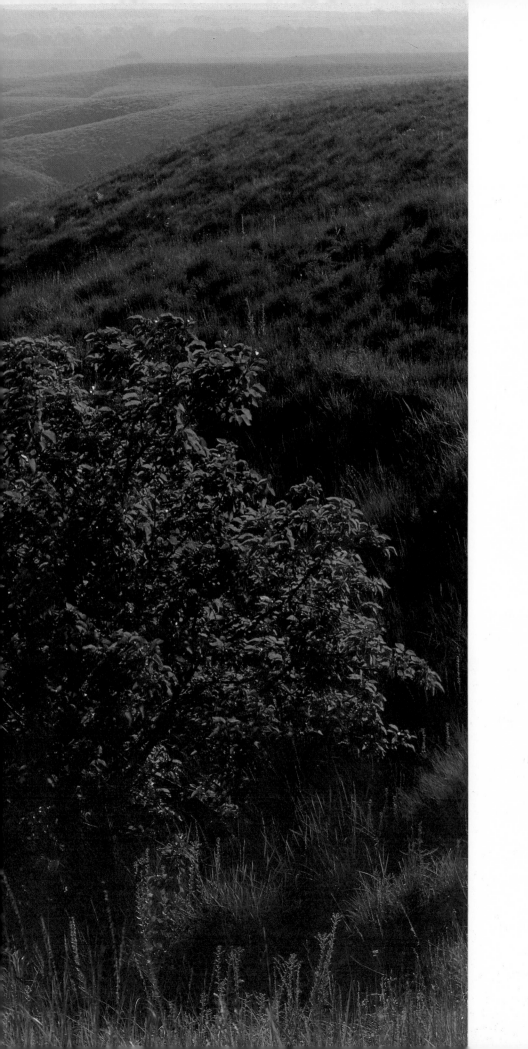

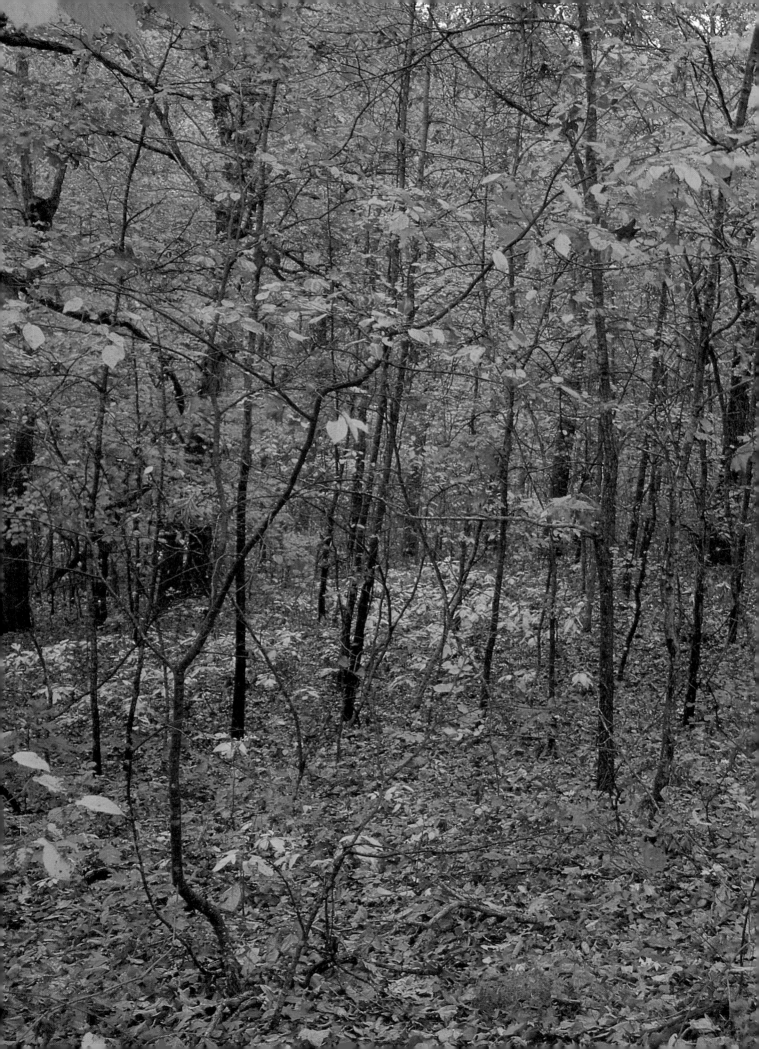

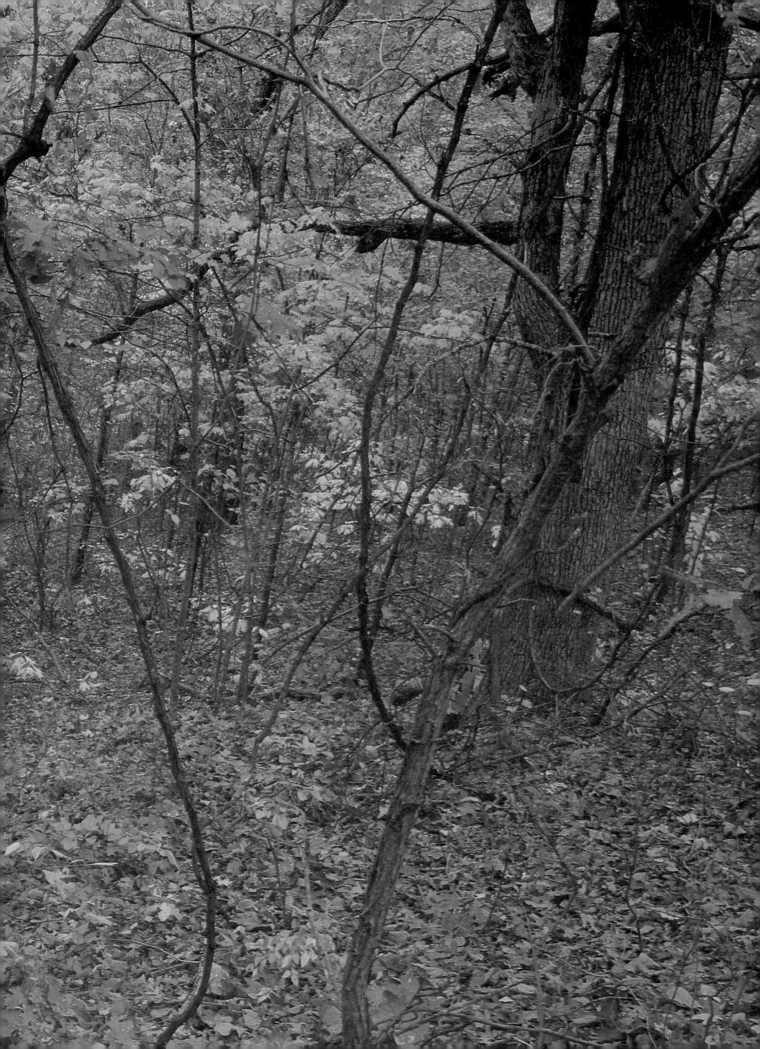

A rainfall created this waterfall below the spillway at one of Sedan's new city lakes.

Fog settles on Lake Sherwood southwest of Topeka.

Pages 28–29. Storm approaches the Konza Prairie near Manhattan.

Pages 30–31. Flint Hills wildflowers near Cedar Point in Chase County.

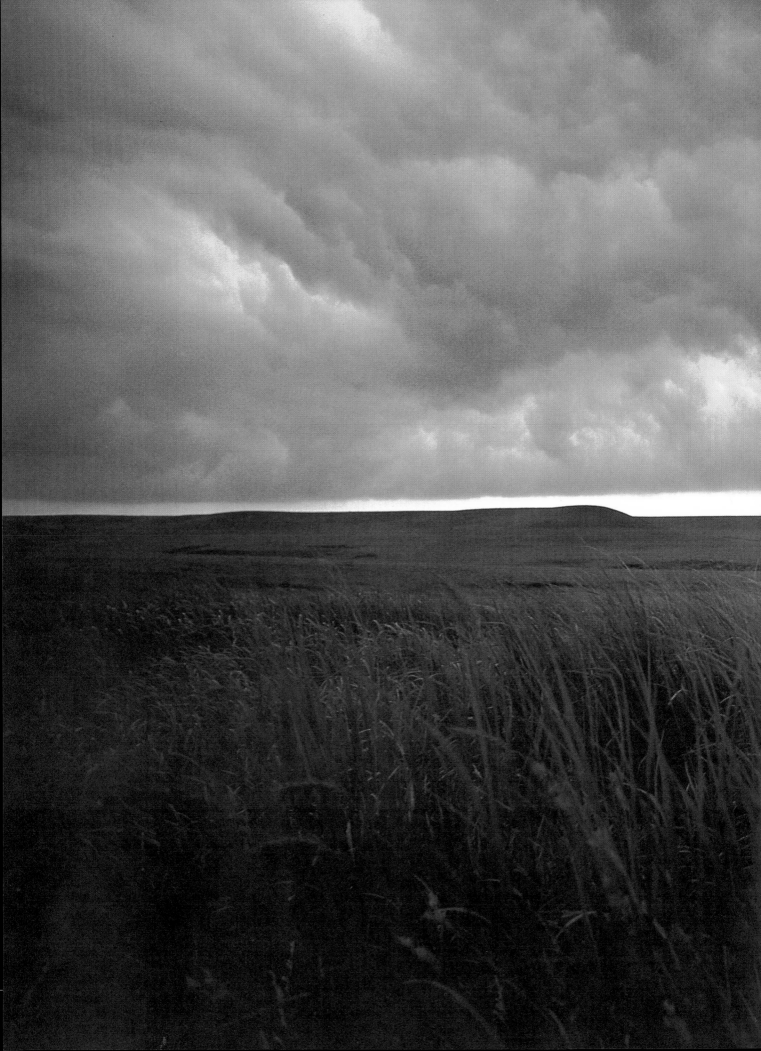

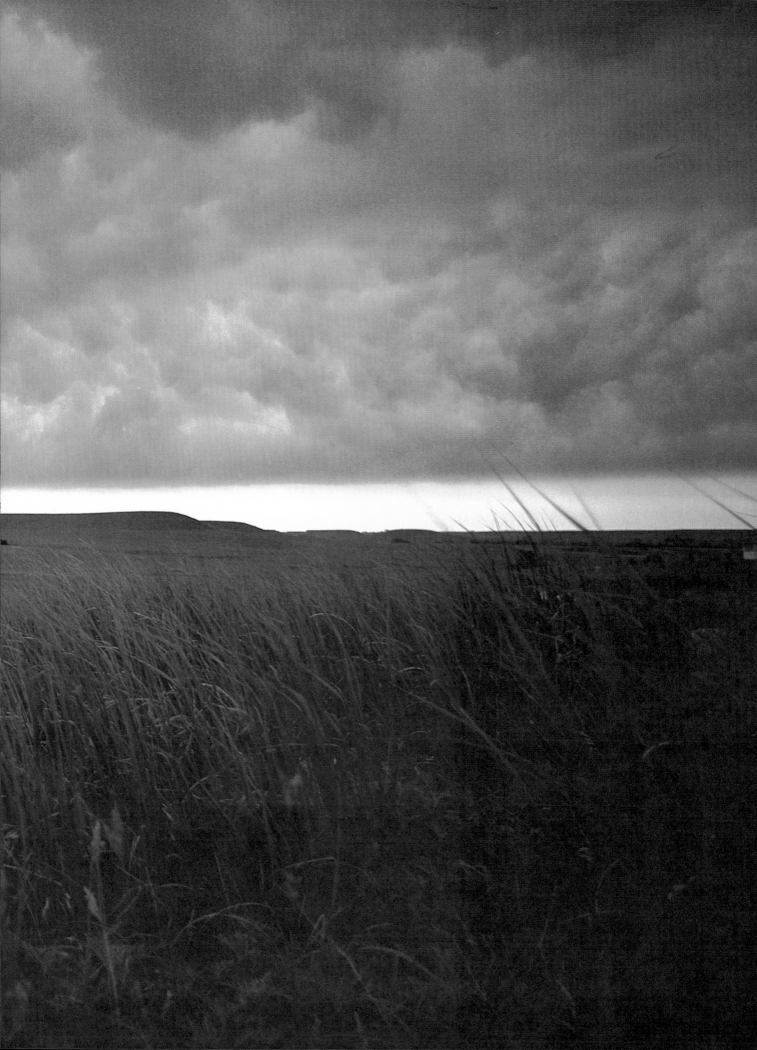

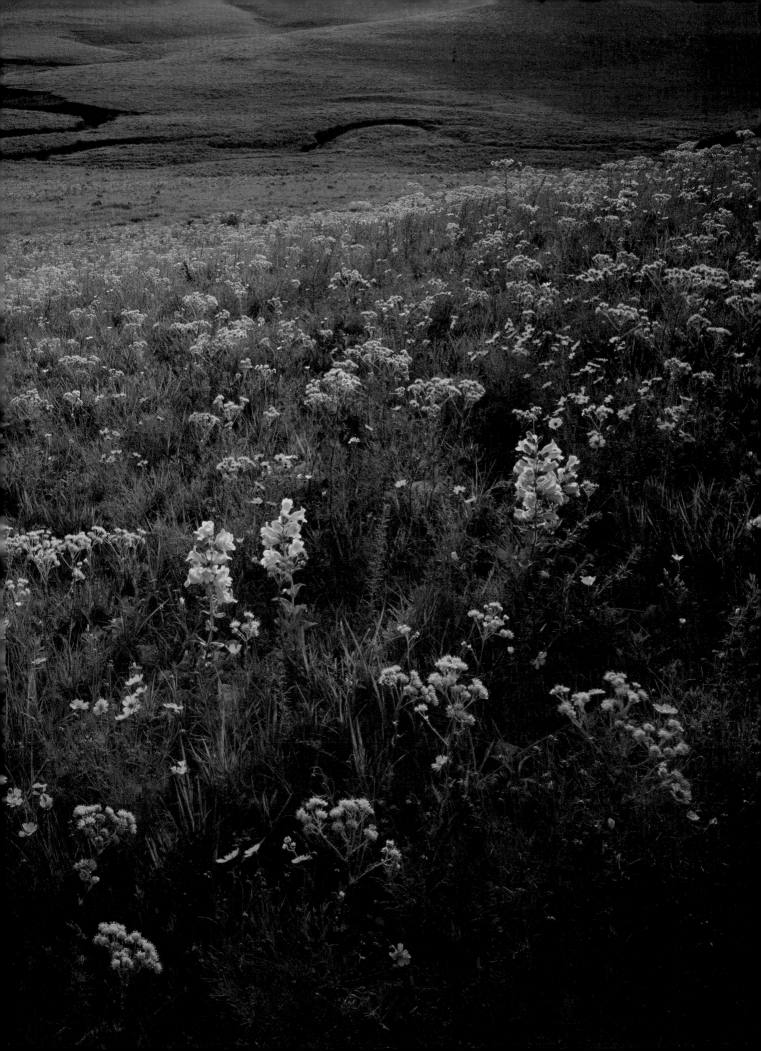

*T*he August sun sets these wild grasses aglow near Lawrence.

*F*lint Hills wildflowers (large-flowered beardtongue in foreground) near Cedar Point in Chase County.

*P*ages 34–35. Flint Hills wildflowers near Cedar Point in Chase County.

*P*ages 36–37. Bales of hay on a Flint Hills farm.

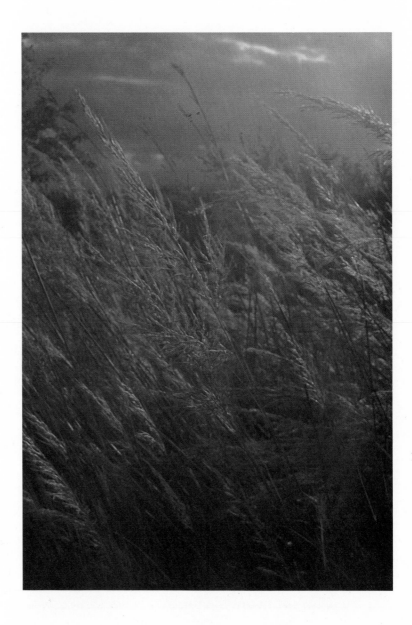

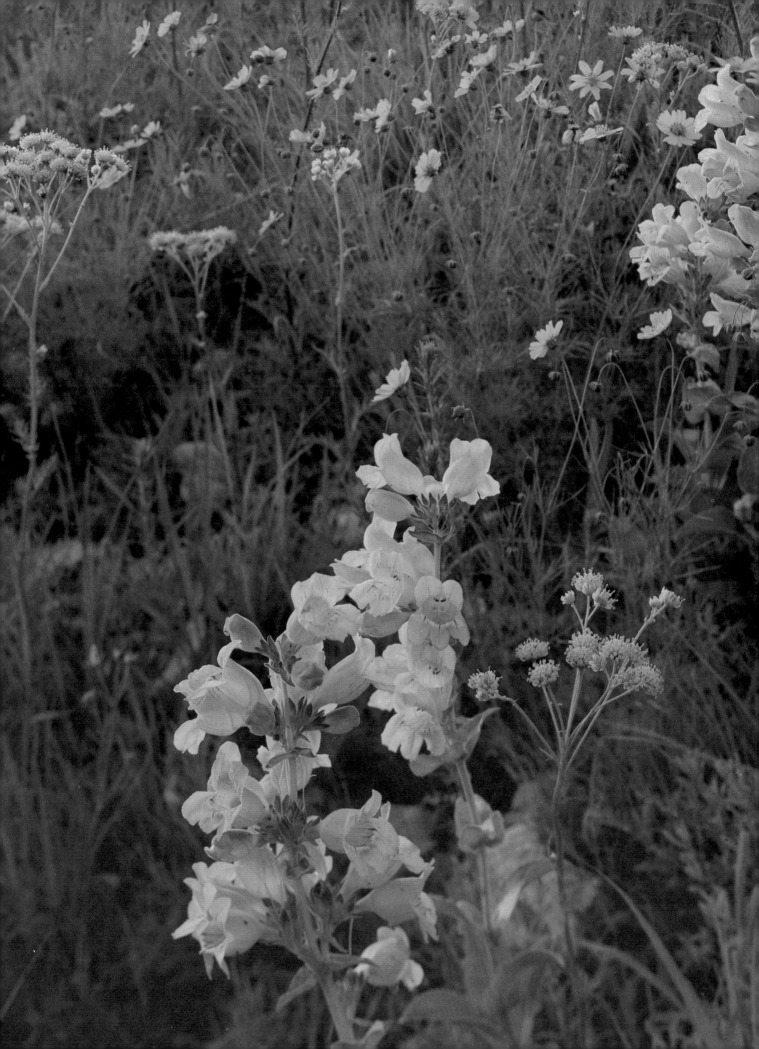

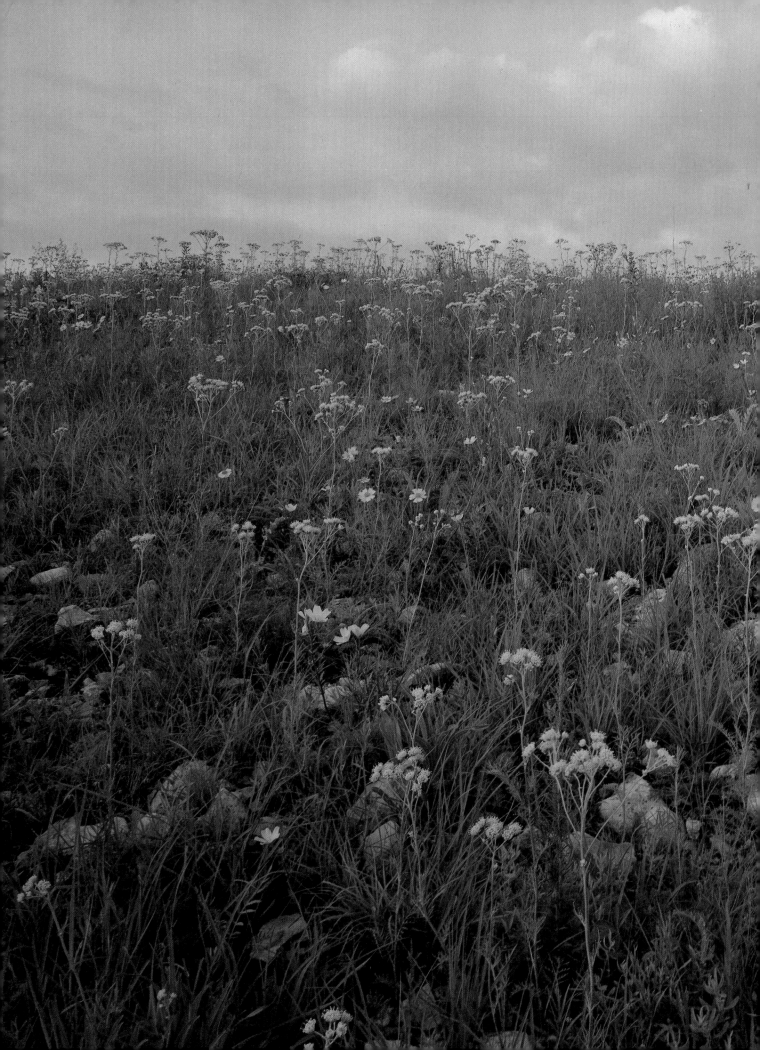

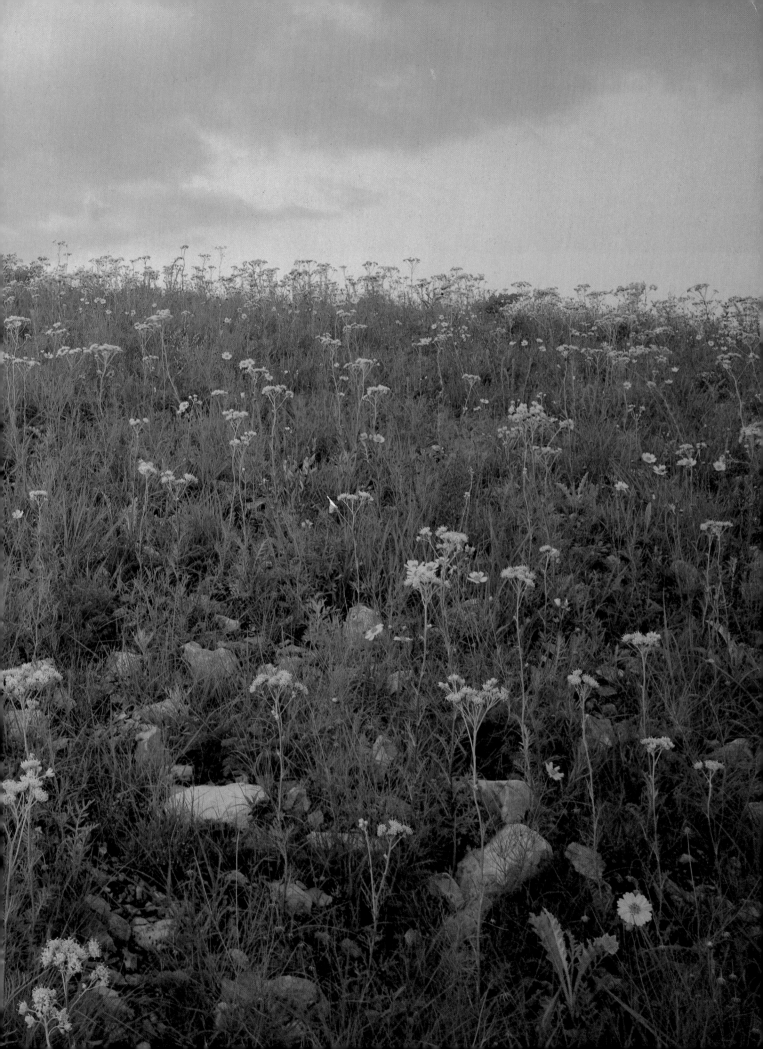

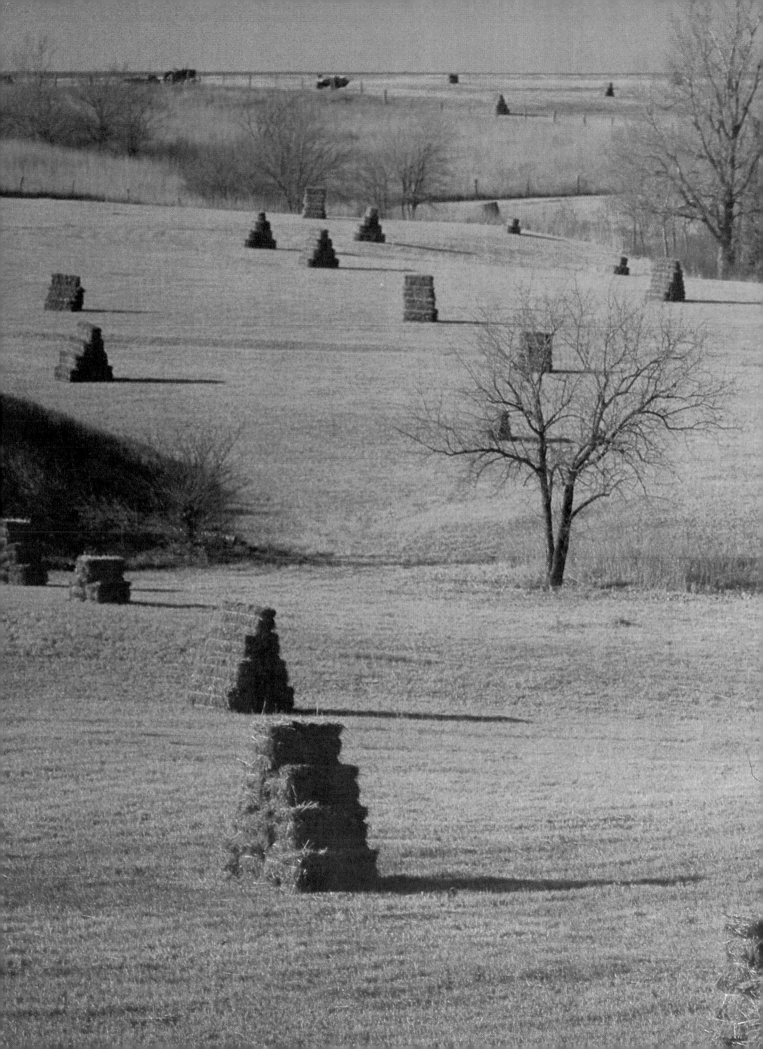

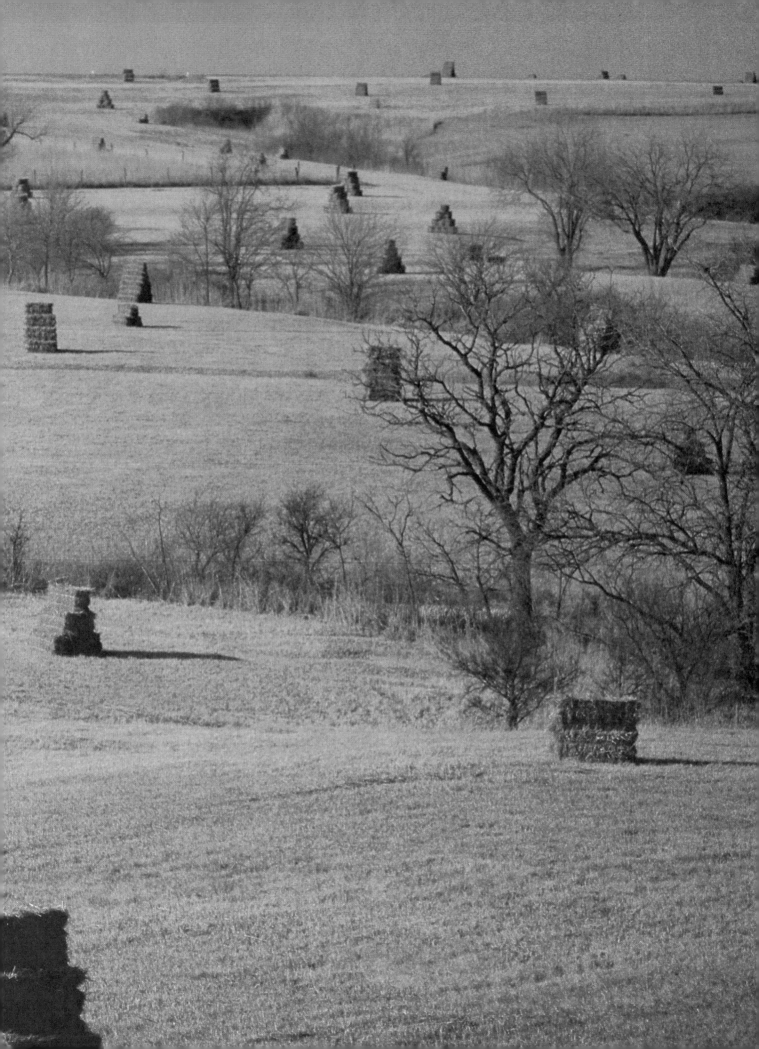

Sunrise over a central Kansas lake.

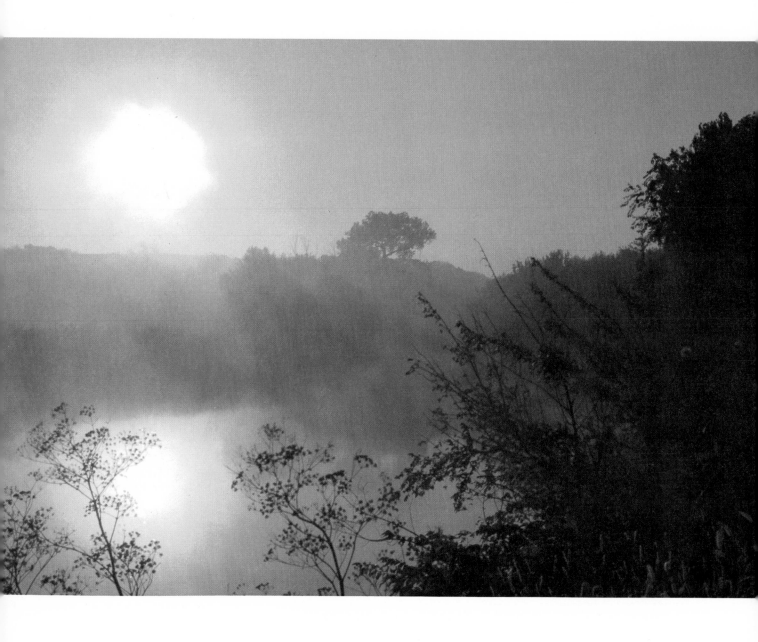

*H*erd of elk on Maxwell Game Preserve near McPherson.

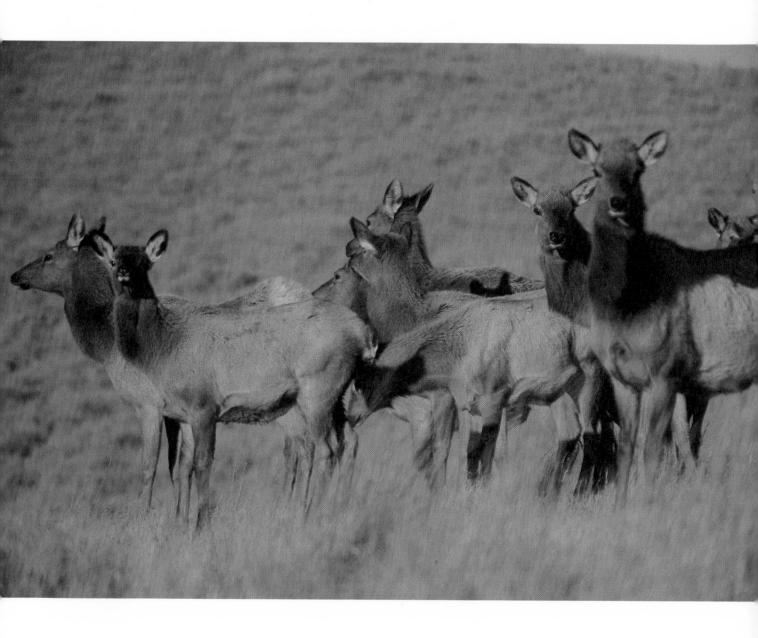

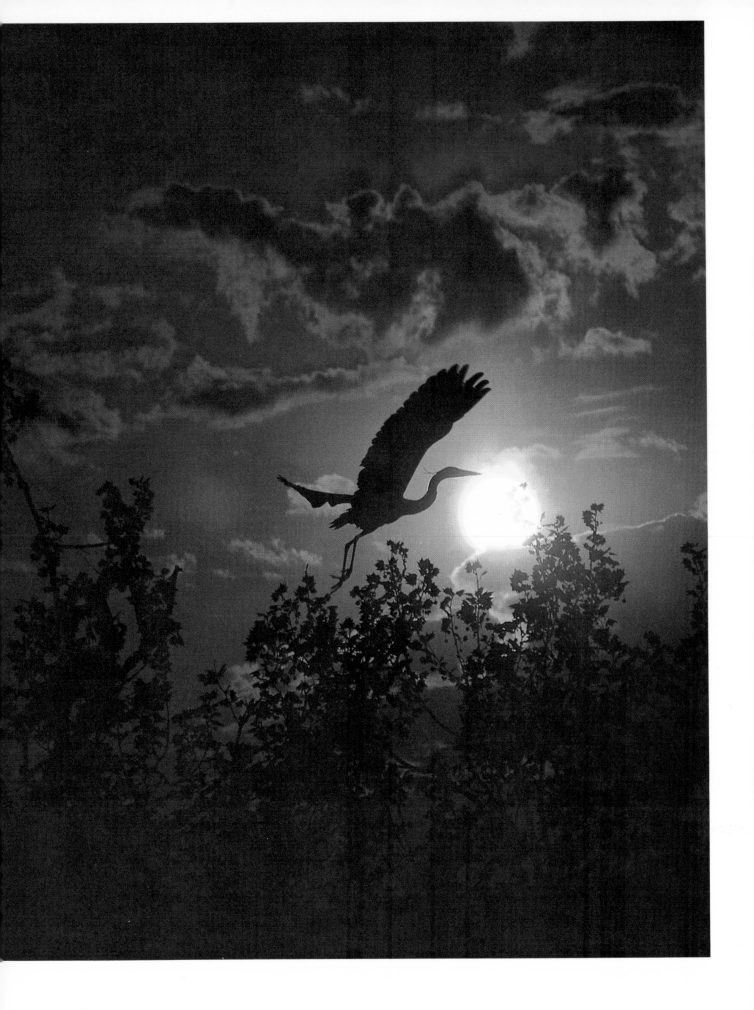

Great blue herons atop a stand of sycamores near Lake Perry north of Lawrence.

Early morning at Cheyenne Bottoms Waterfowl Refuge near Great Bend.

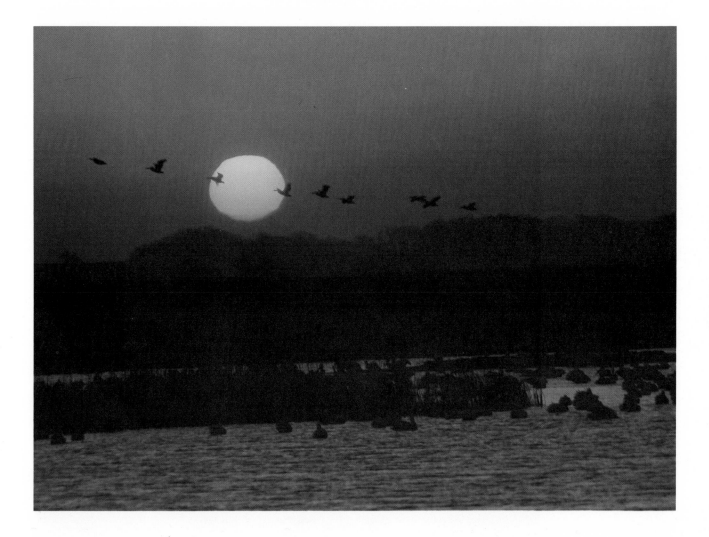

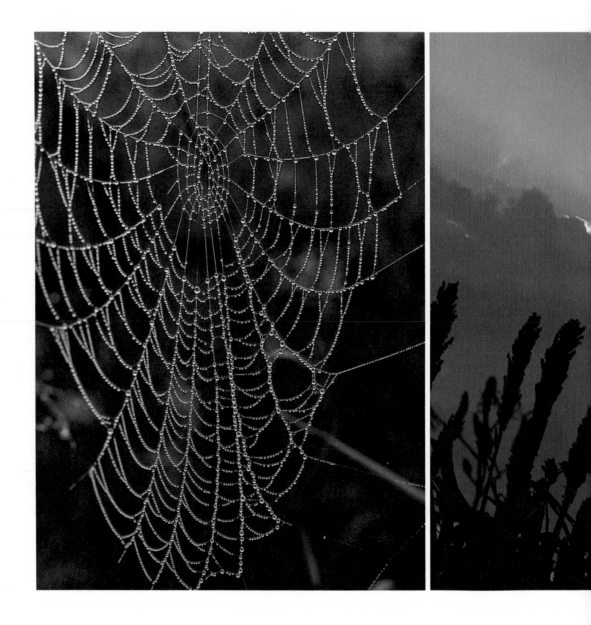

*F*ield of milo in central Kansas.

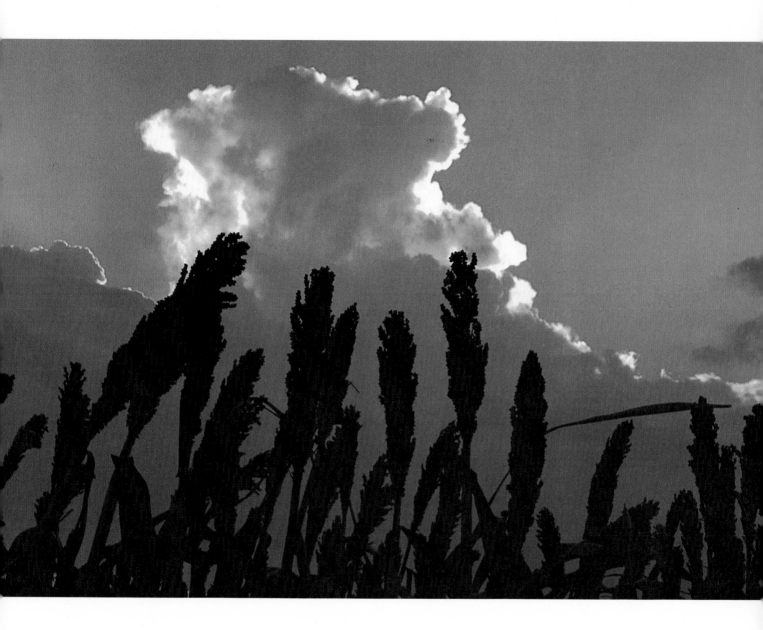

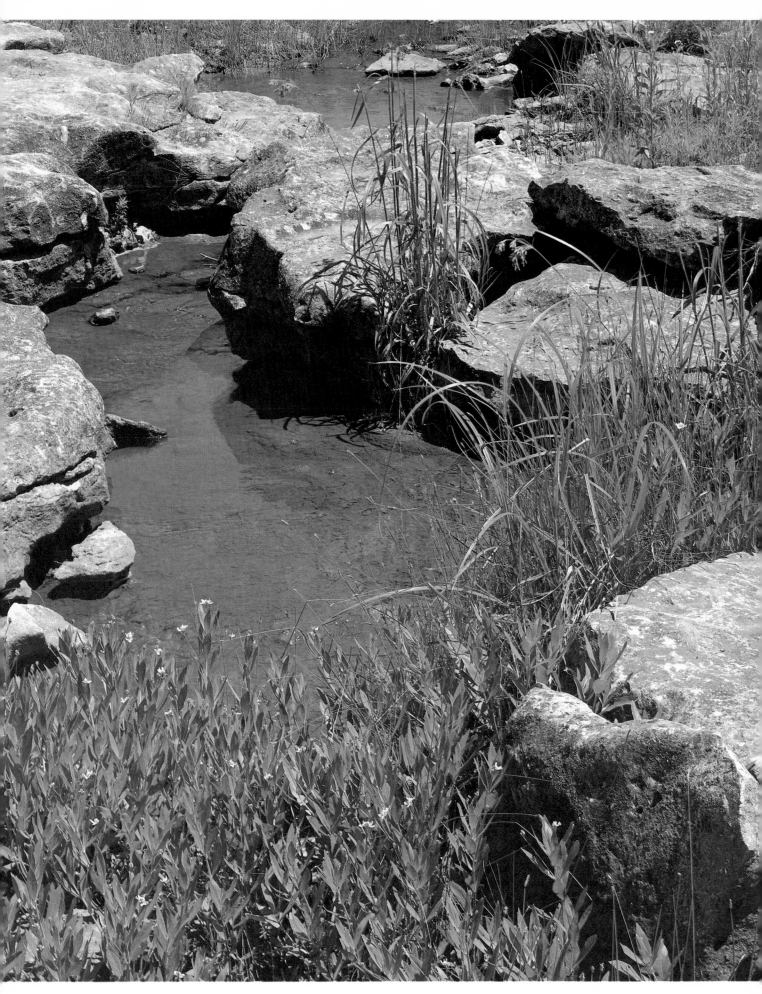

Stream near Leon in Butler County.

Redhead duck at Inman Marsh in McPherson County.

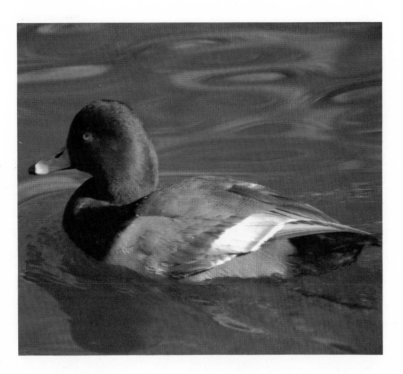

*B*uffalo herd on the Maxwell Game Preserve near McPherson.

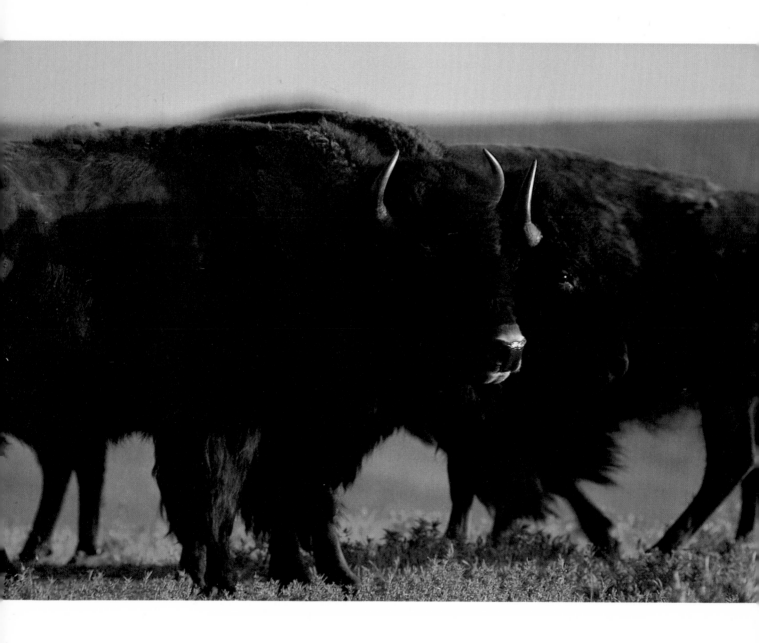

Great blue heron near Buffalo in Wilson County.

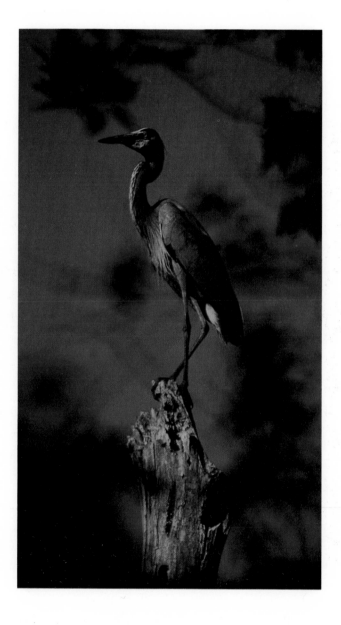

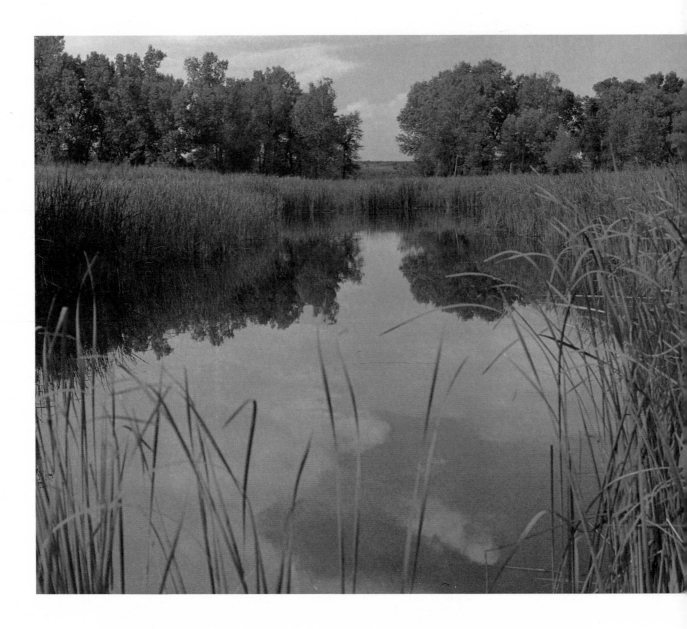

*B*ald eagle.

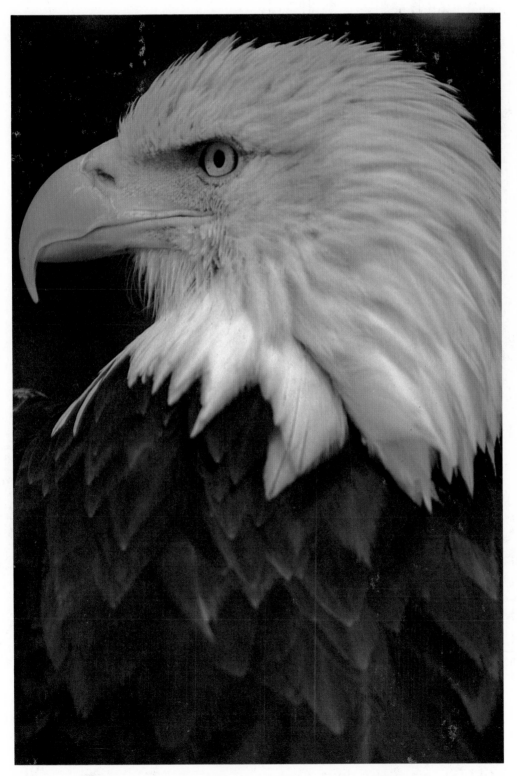

Sun sets on the Maxwell Game Preserve near McPherson.

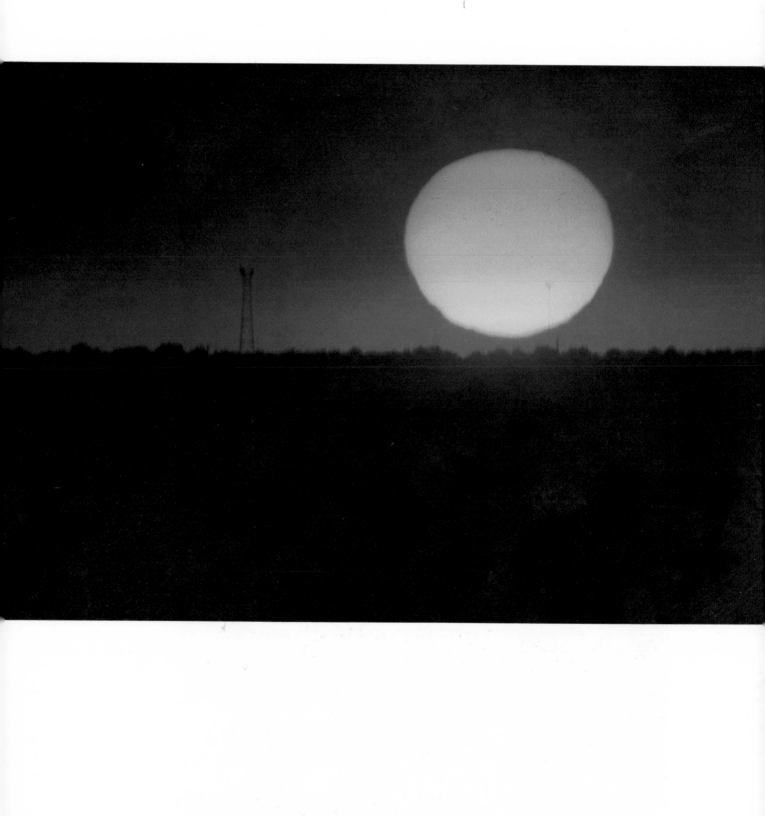

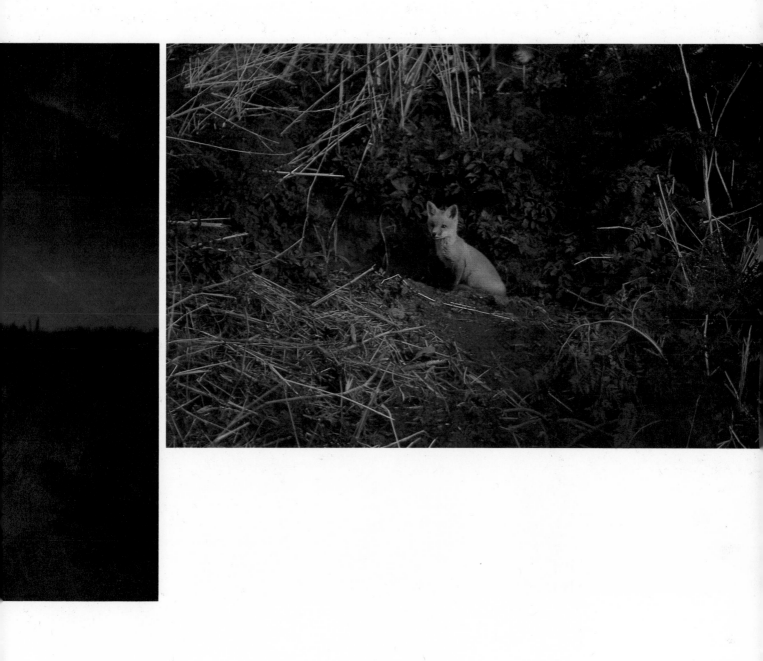

*R*ed fox pup near Chanute.

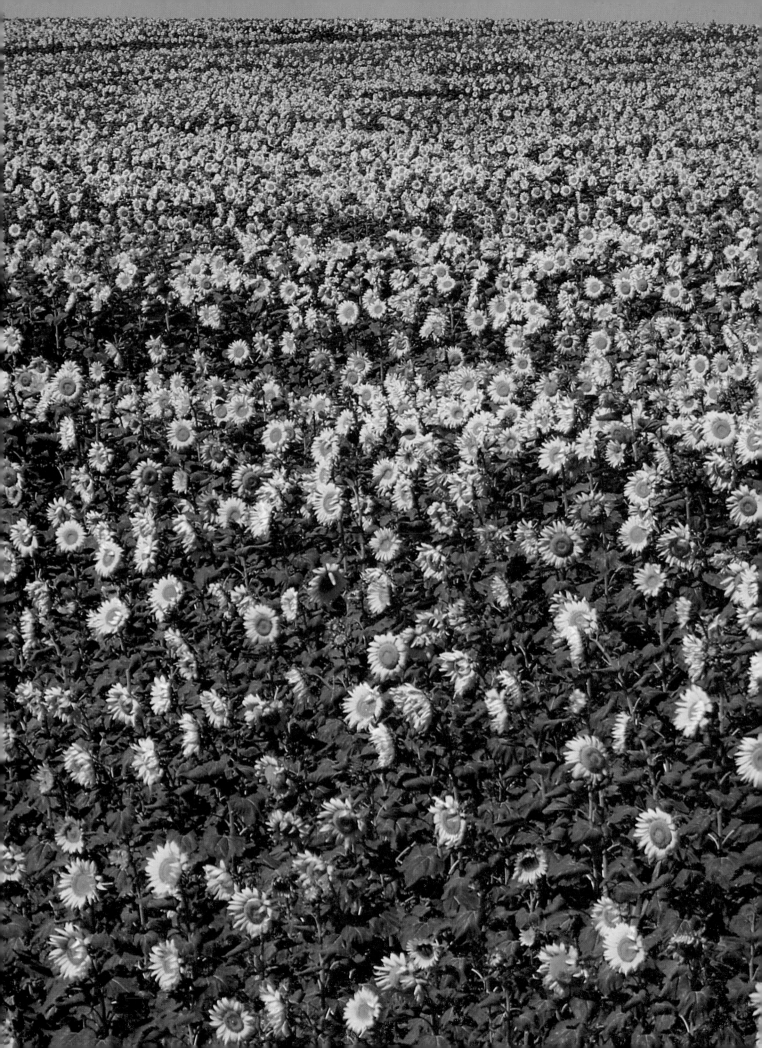

*S*unflower farm in Thomas County.

*T*ulips on the University of Kansas campus in Lawrence.

*P*ages 54–55. Wheat ready for harvest in central Kansas.

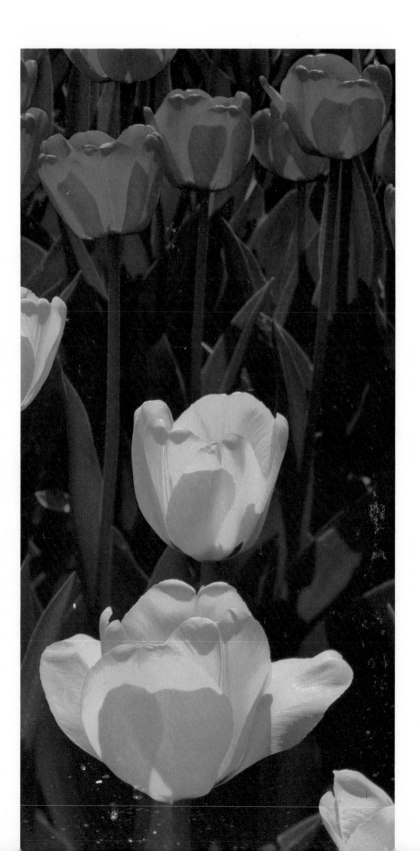

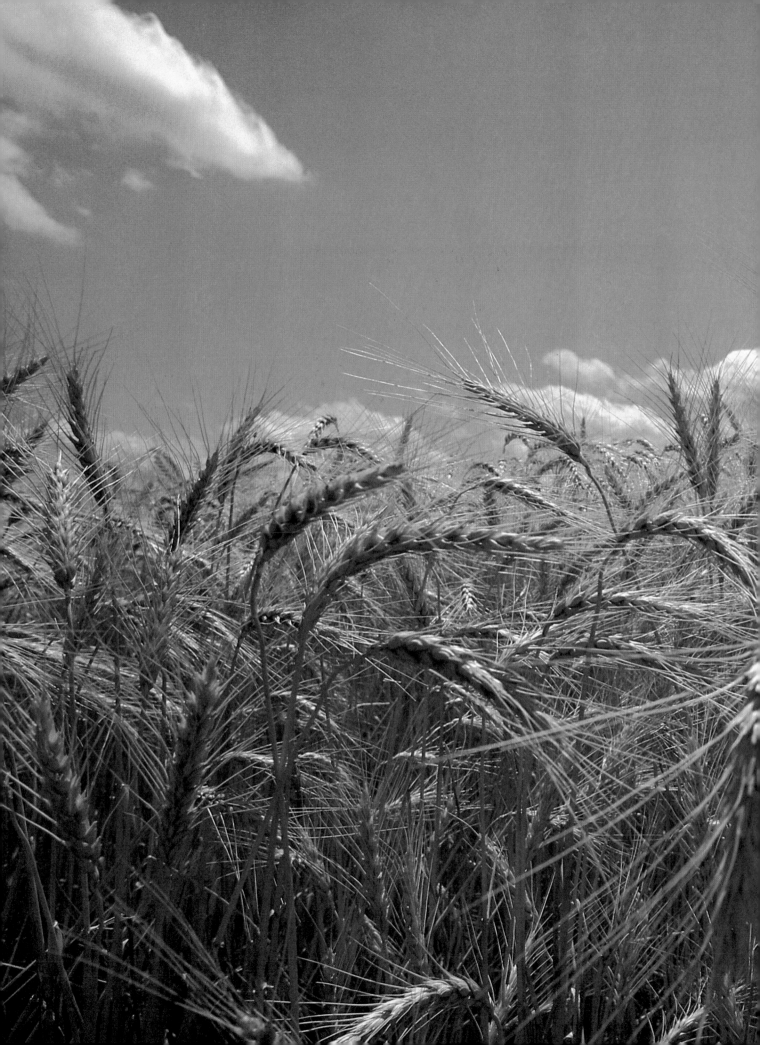

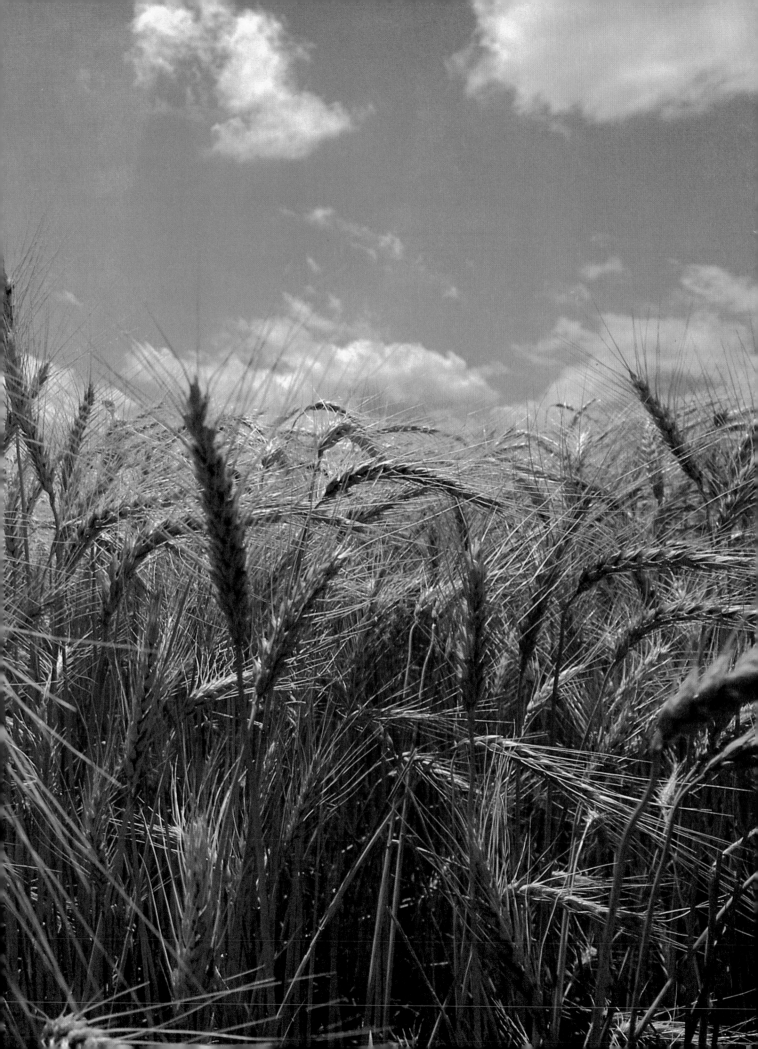

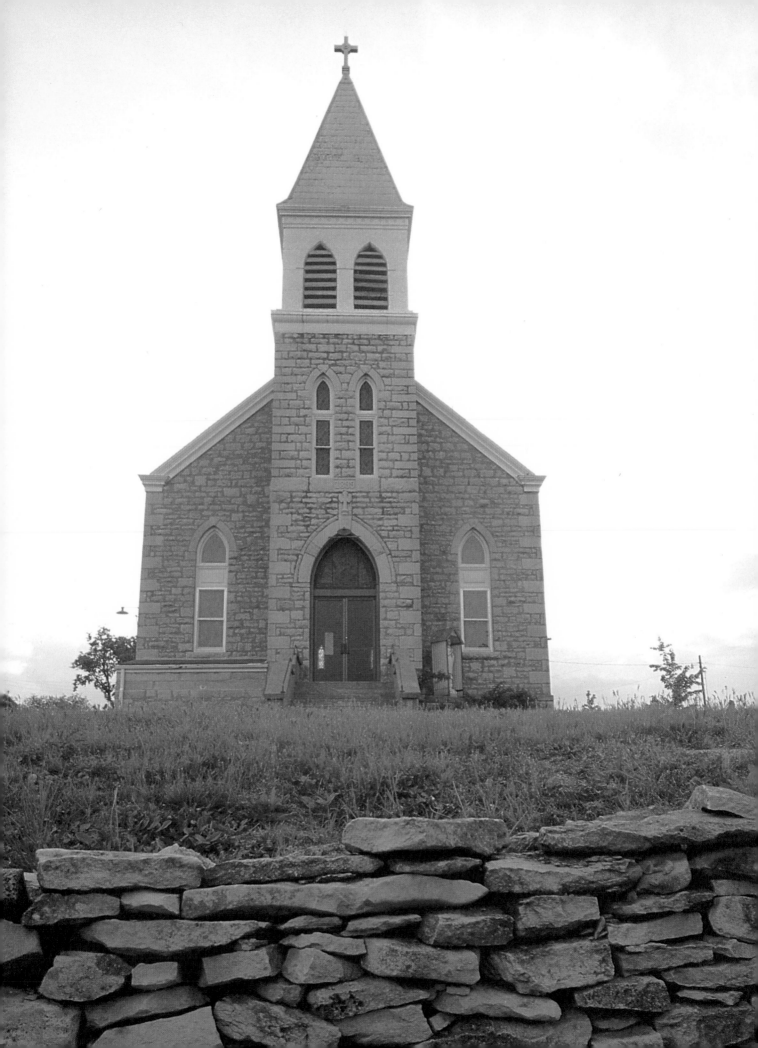

Holy Family Church in Alma.

Grain elevator near Skiddy in the Flint Hills.

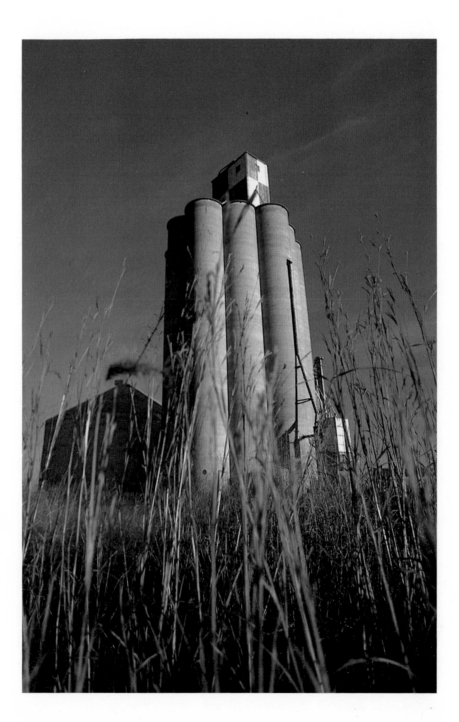

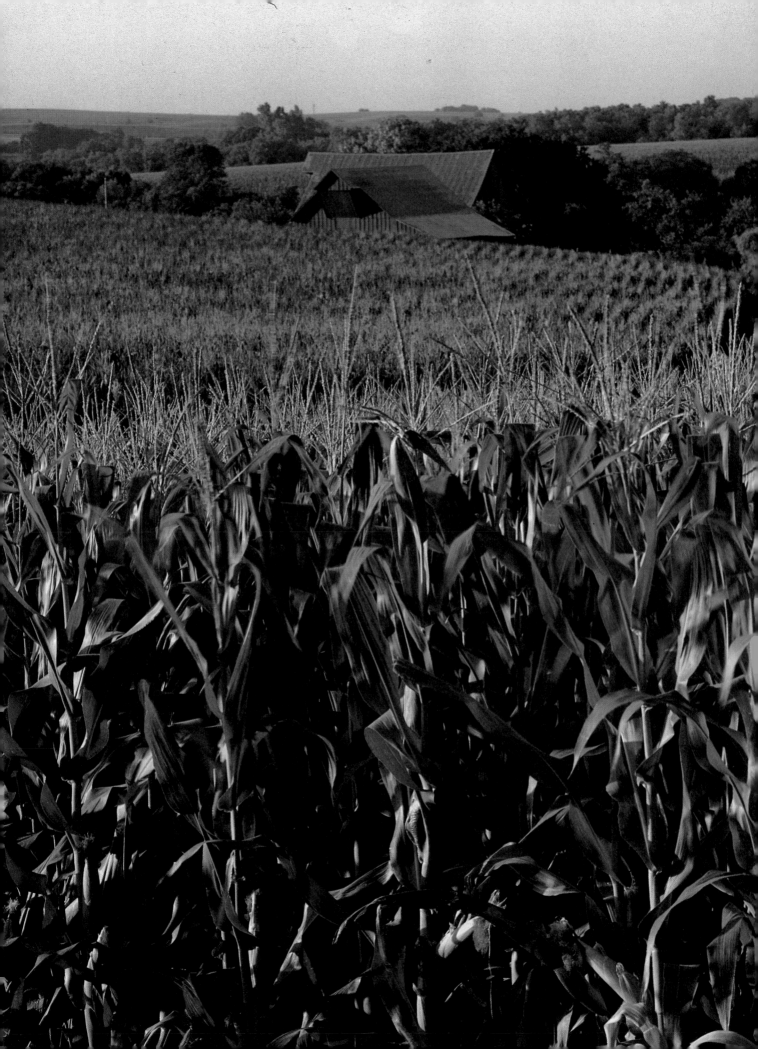

*C*ornfield near Troy in Doniphan County.

*S*unset on farm machinery on Flint Hills farm.

*P*ages 60–61. Windmills dot the Kansas landscape.

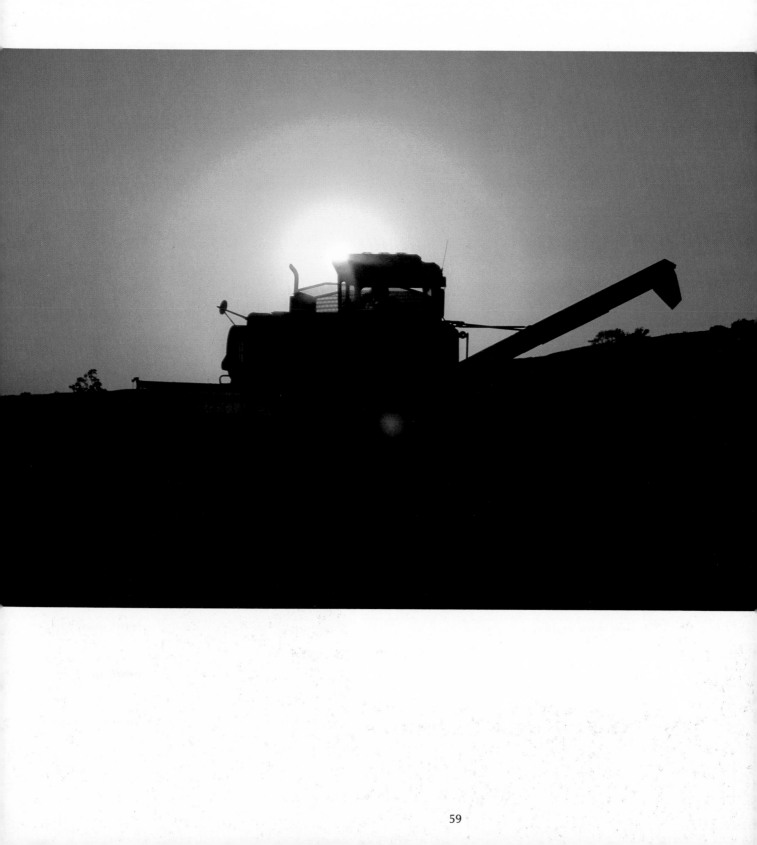

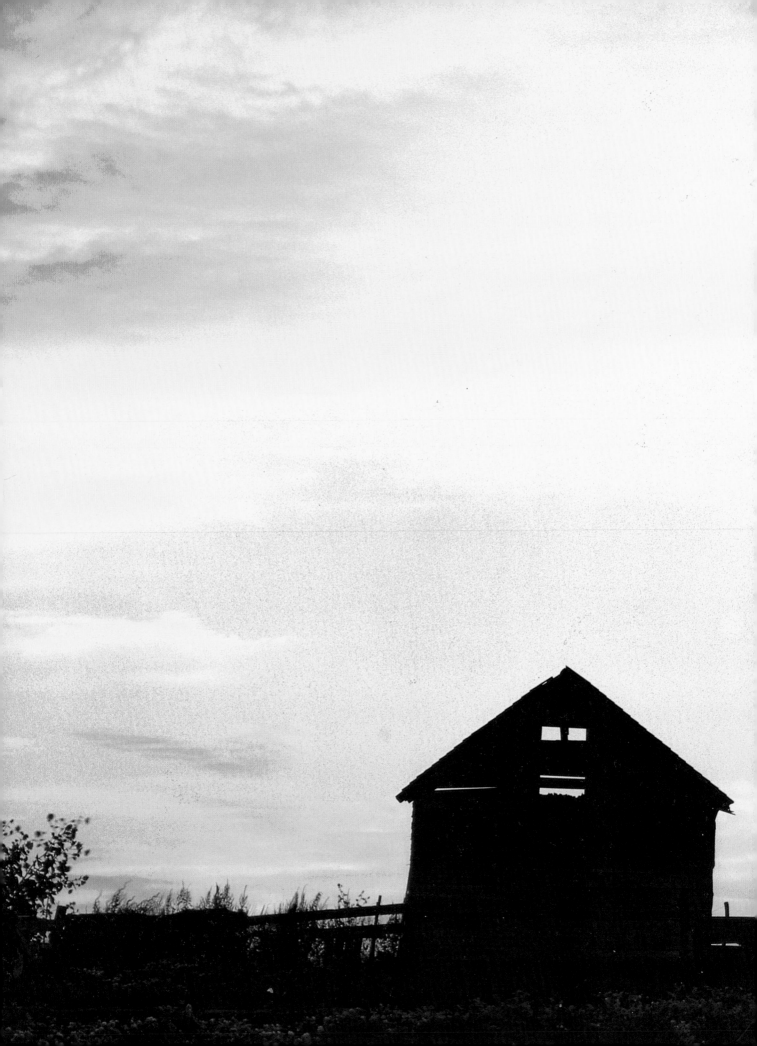

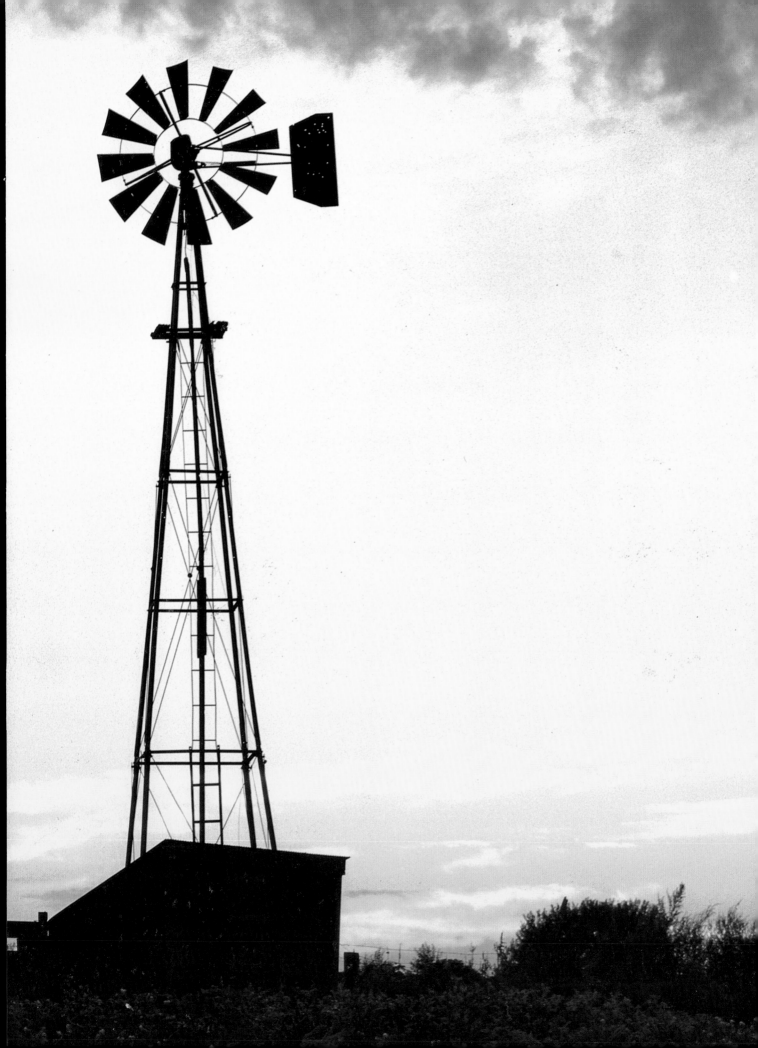

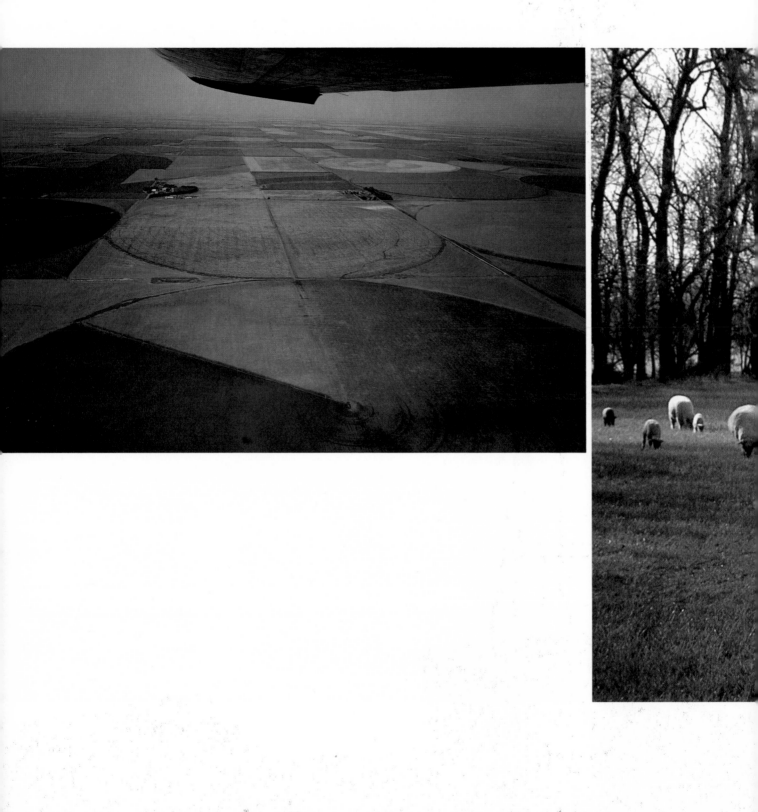

Aerial view of Thomas County shows circles of green vegetation created by irrigation.

Sheep flock on farm near Harper.

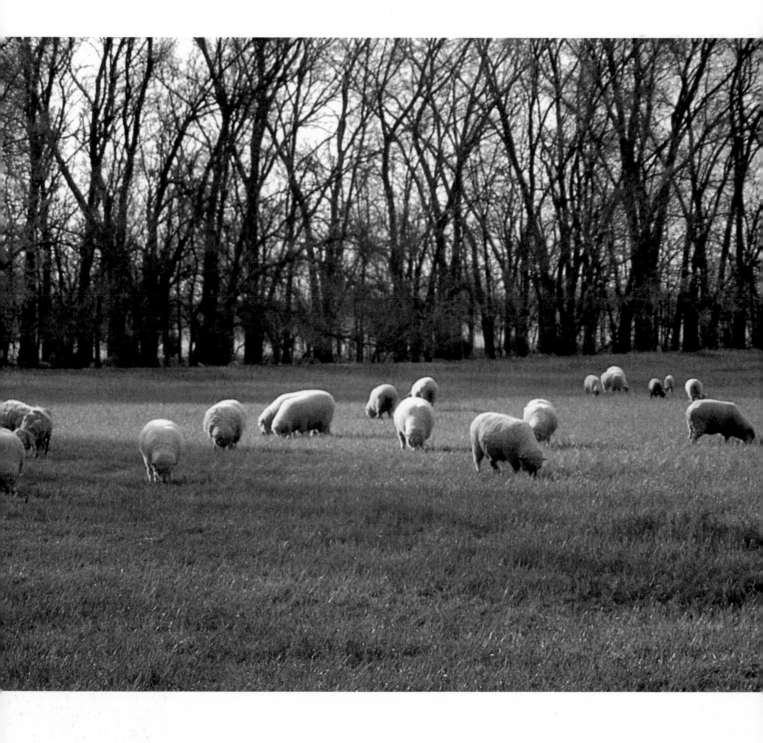

A misplaced goat checks the view from the second story of
an old stone barn in northeast Kansas.

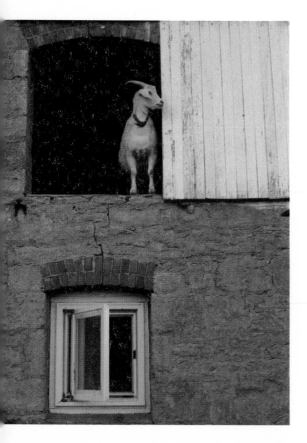

*S*unrise over a Harvey County farm.

*P*ages 66–67. Railroad tracks and grain elevators are the focal points for many small Kansas towns.

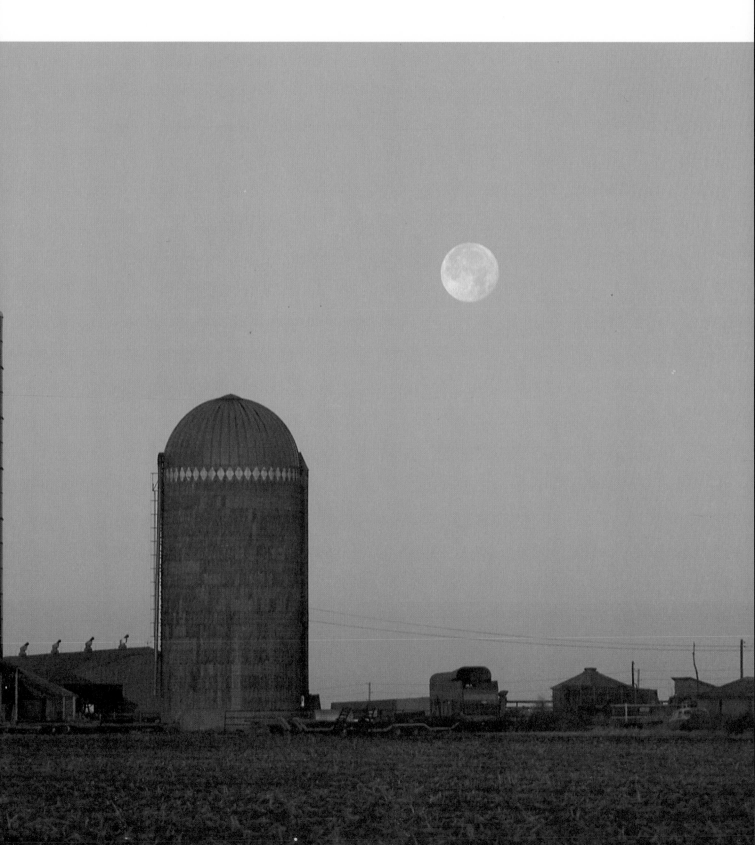

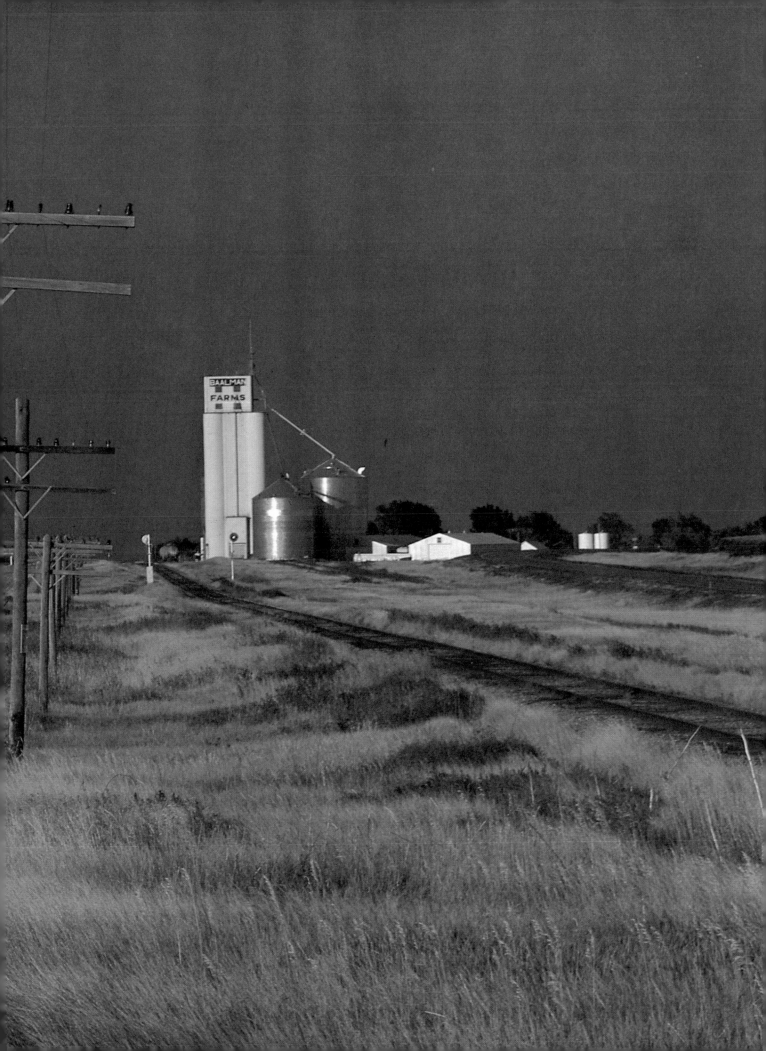

Cultivator in central Kansas.

*B*arn interior in central Kansas.

*P*ages 70–71. Fall cattle drive in Flint Hills.

*P*ages 72–73. One-room schoolhouse near Elmdale in central Kansas.

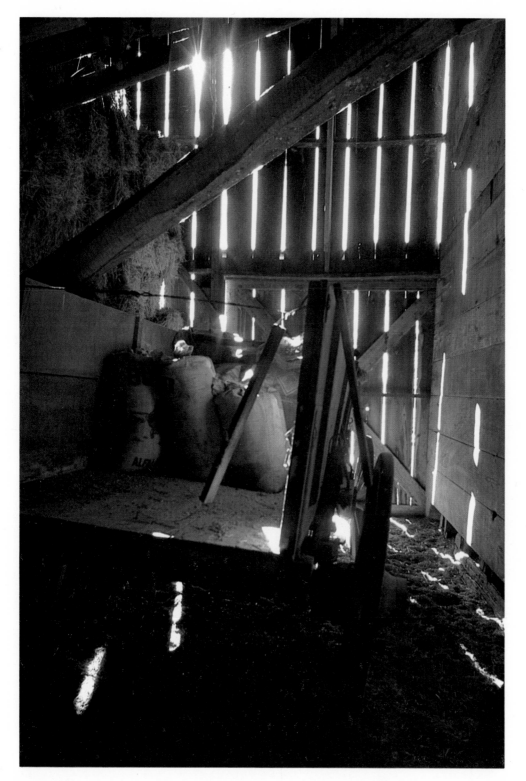

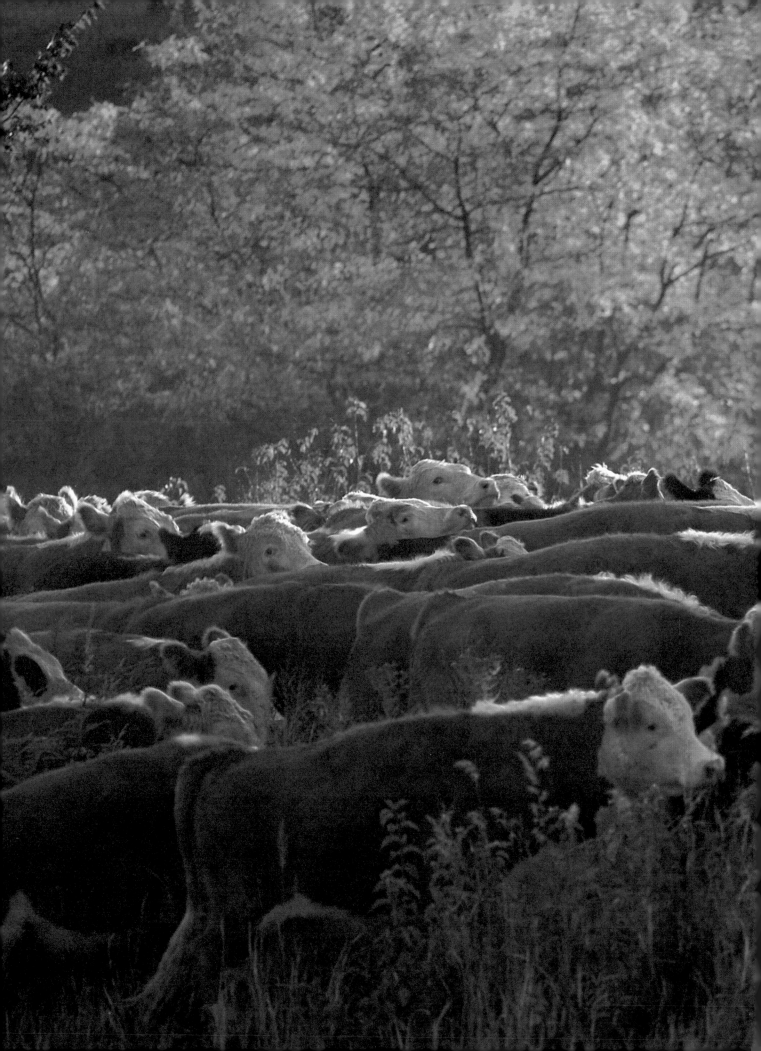

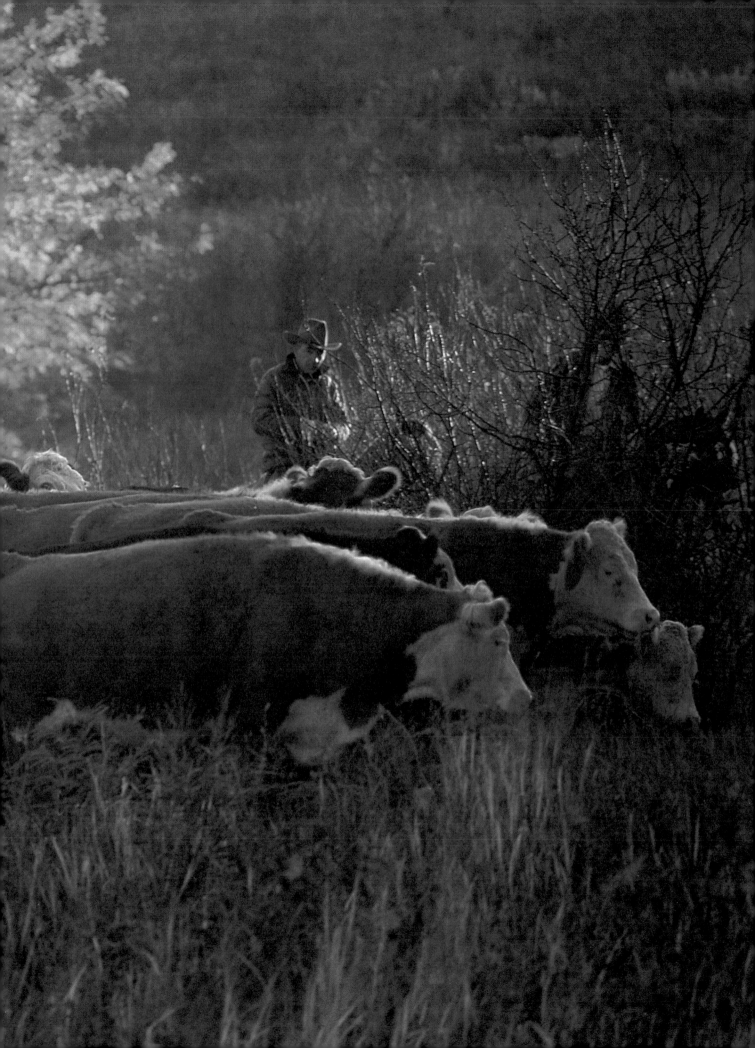

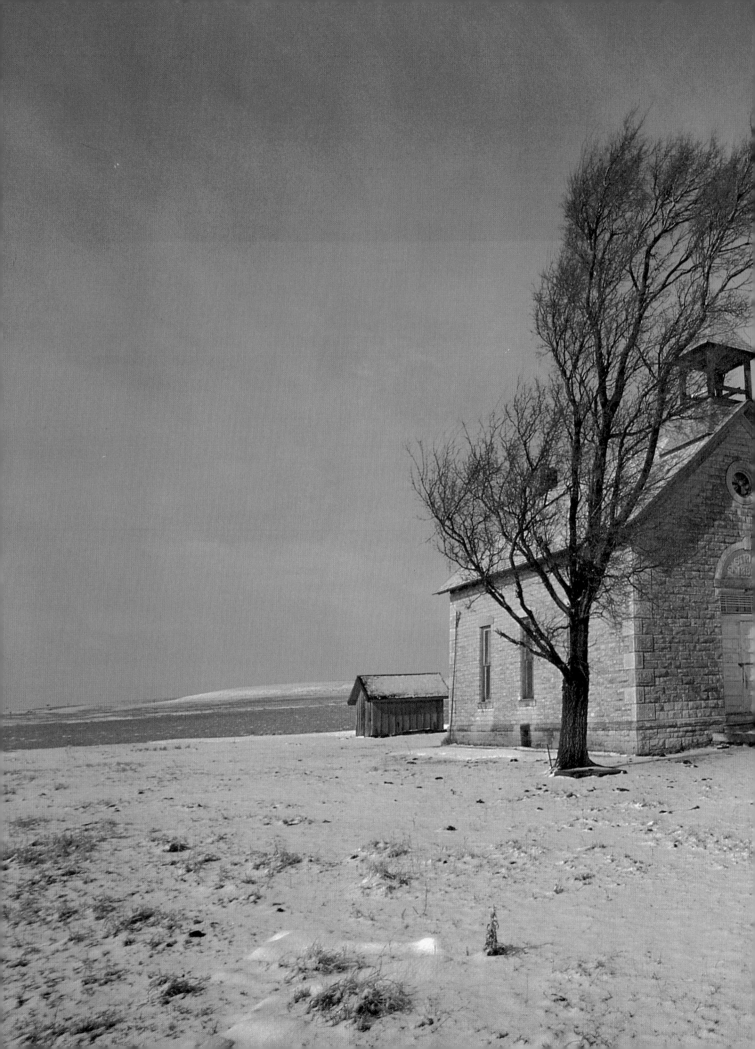

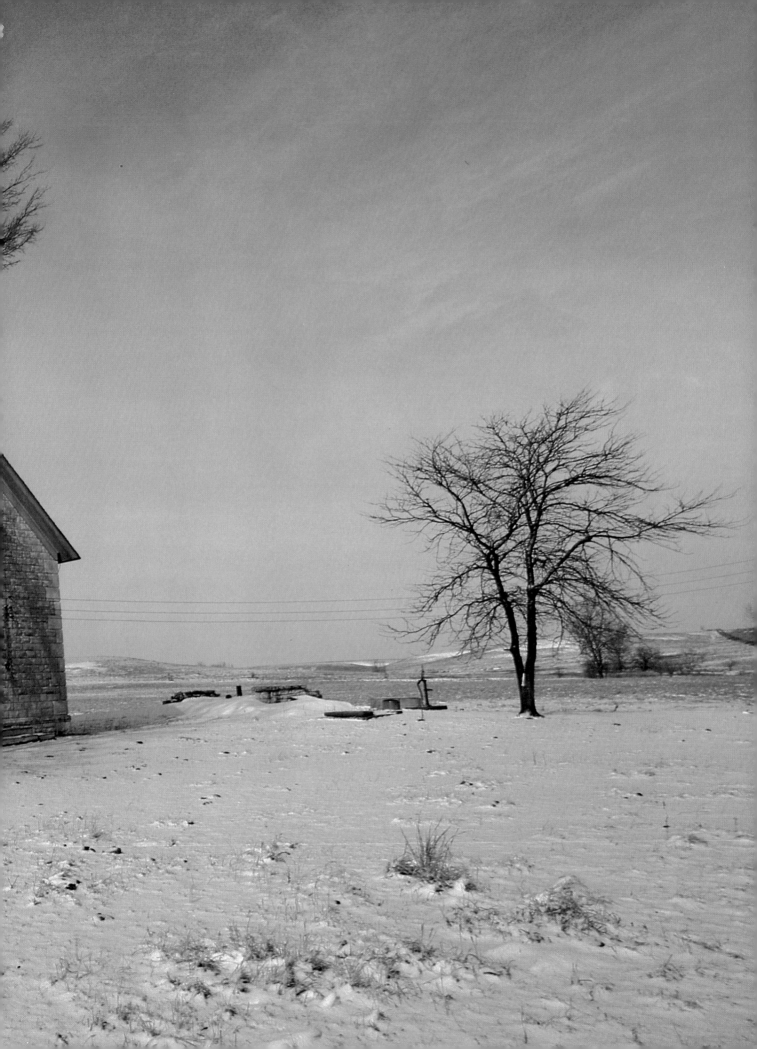

A blizzard on the prairie leaves its trace in many forms.

*H*olton farm scene.

*P*ages 76–77. Winter farm scene near Topeka.

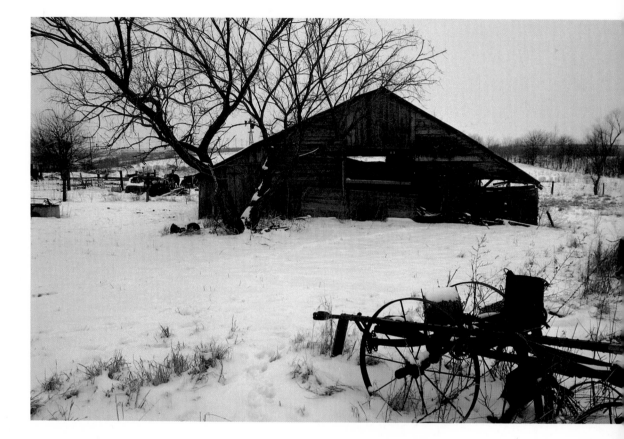

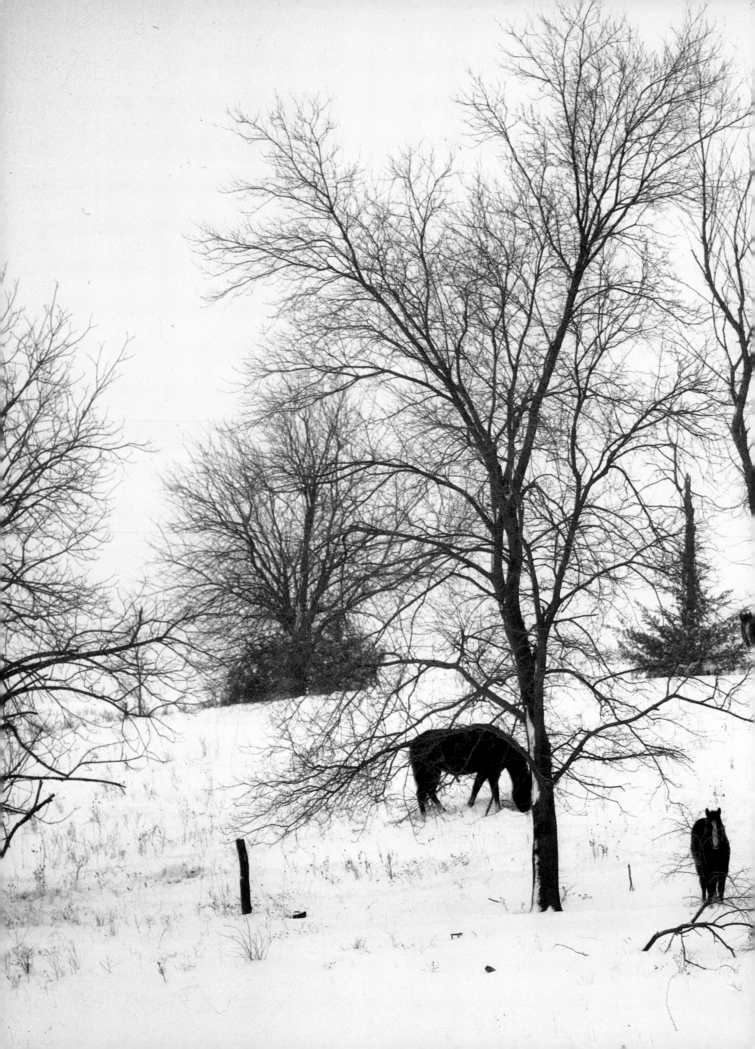

Bales of hay wait through winter.

Snow-covered logs on a Moundridge farm.

Frost-covered trees in Ottawa County.

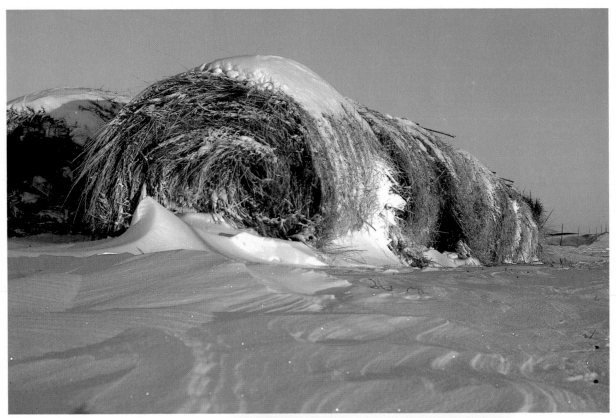

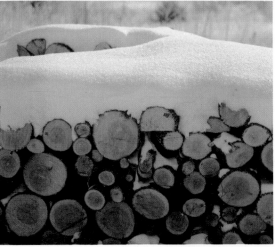

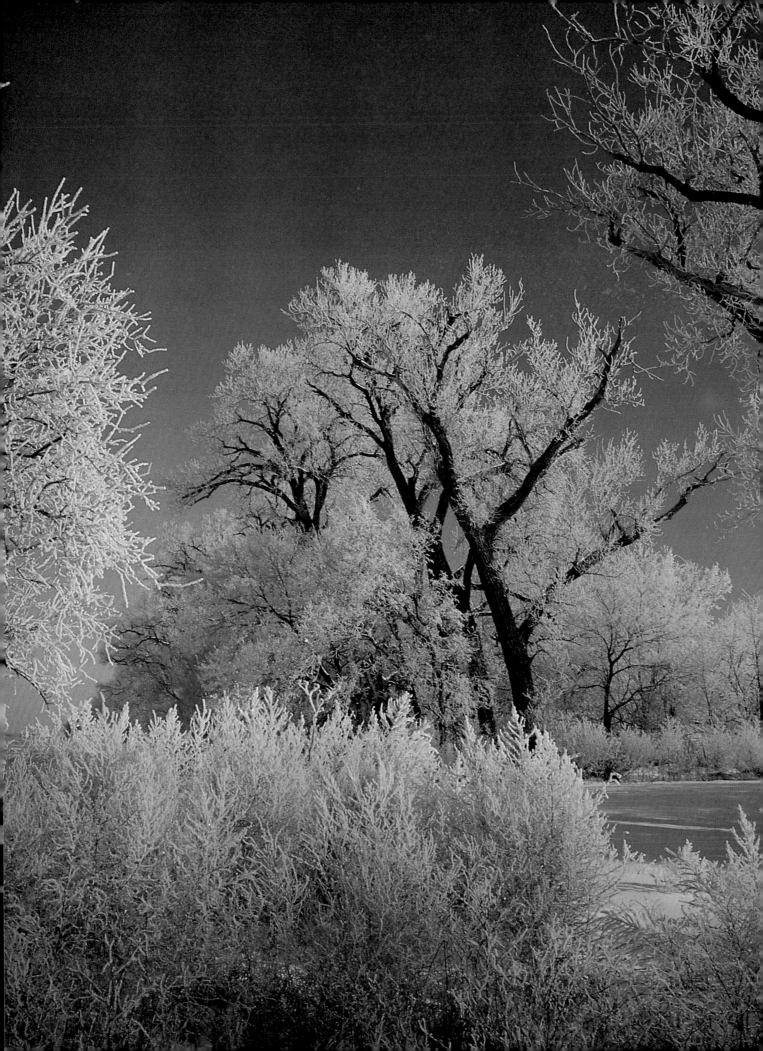

Winter landscape near Oskaloosa.

An overnight ice storm altered the appearance of this barn near Moundridge.

*W*ater pump on a central Kansas farm.

A Moundridge farm after an ice storm.

*P*am Carvalho gathers wildflowers on her farm near
Baldwin City.

*S*umner County farmhouse.

Fall on the St. Mary College Campus in Leavenworth.

Maple trees line the streets in Baldwin City.

Pages 88–89. Stone fence posts outside the town of Pfeifer in Ellis County.

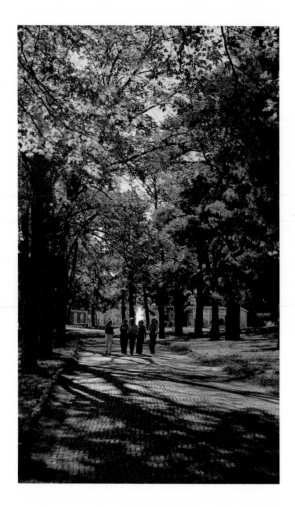

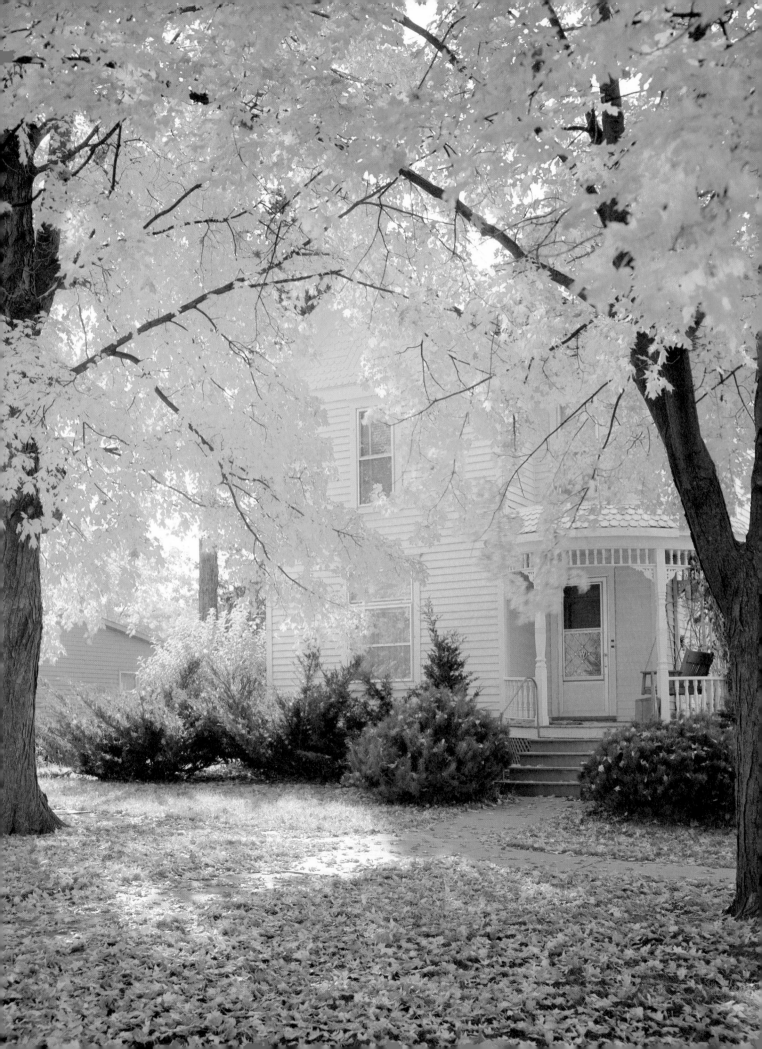

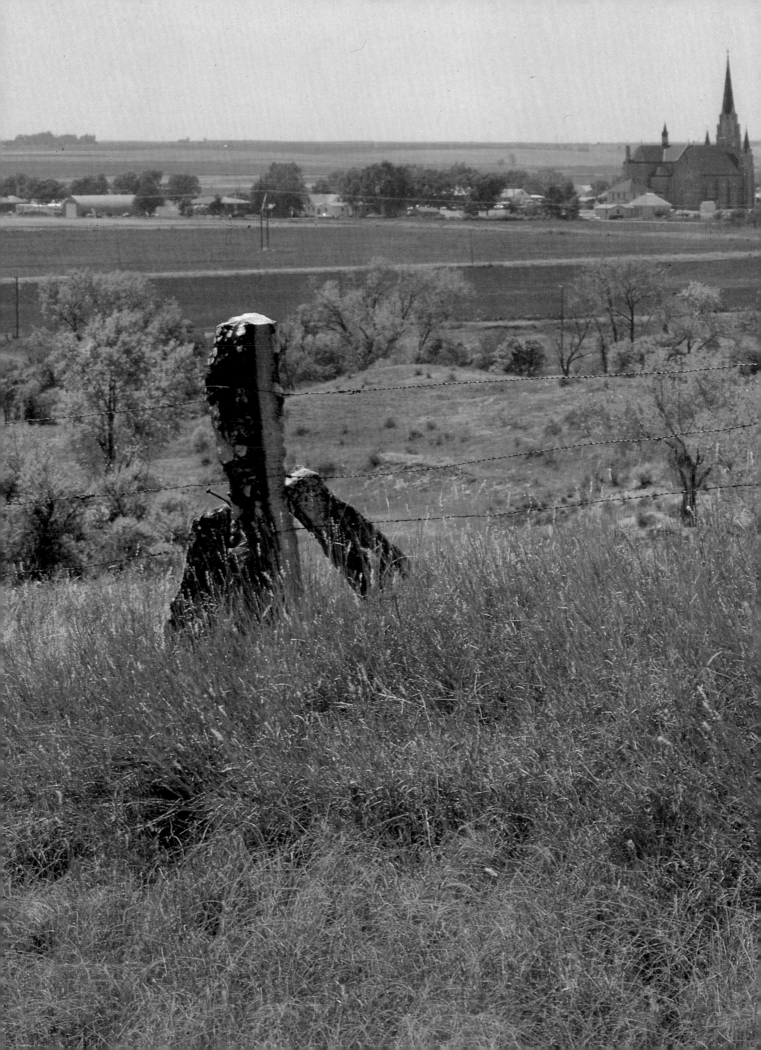

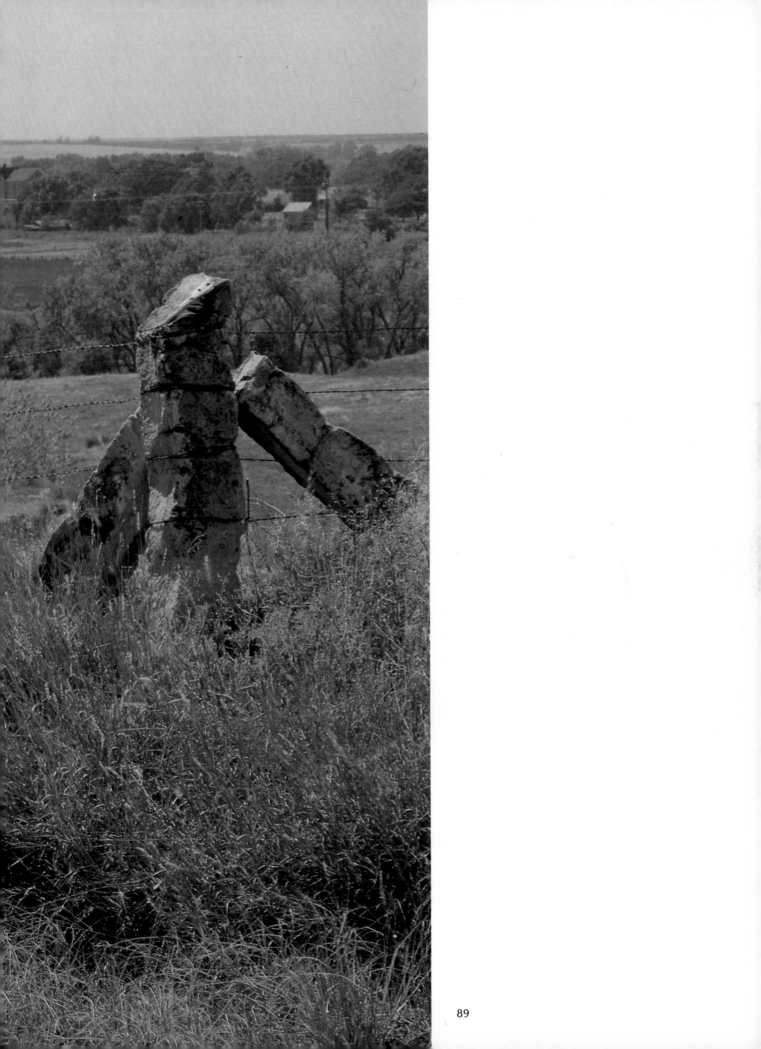

One-room schoolhouse on a ranch in Chase County.

*S*unrise on a Flint Hills farm.

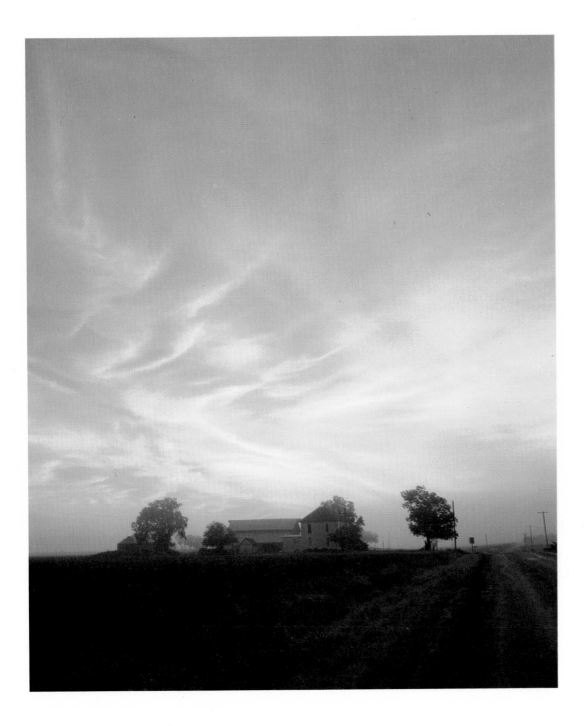

Dusk at a Sumner County farm.

Amish horse and buggy near Hutchinson.

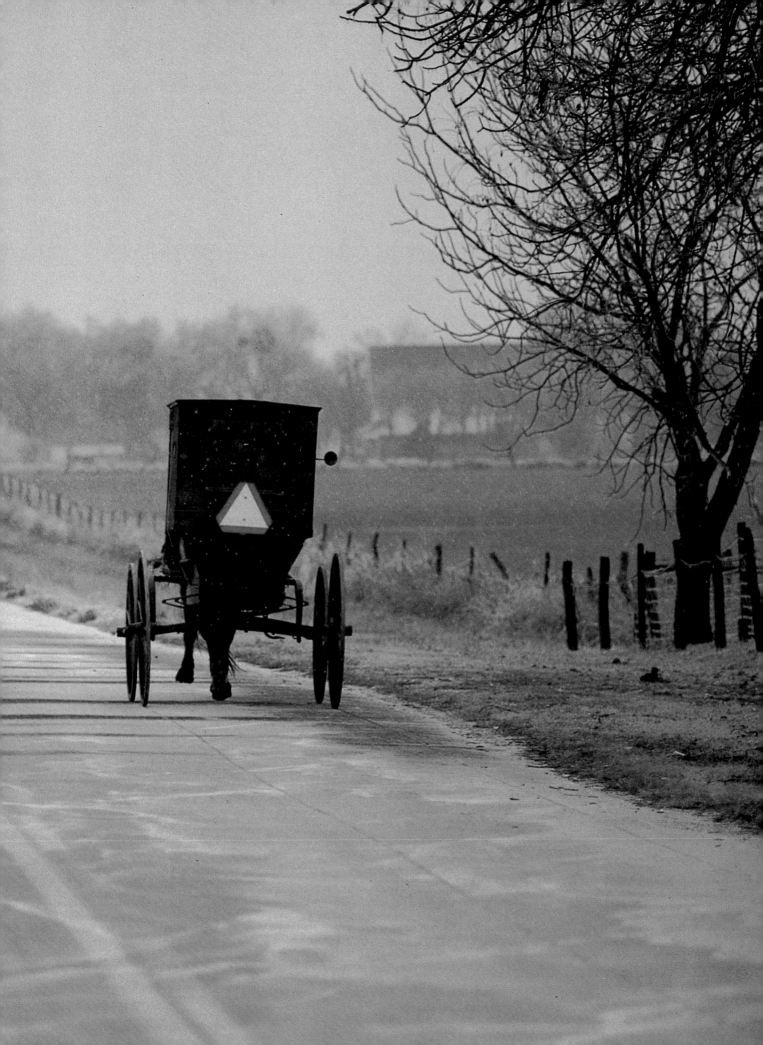

*A*bandoned stone structure in Logan County.

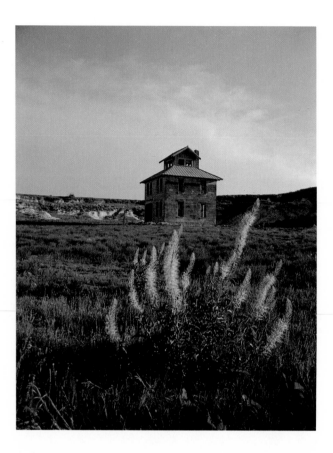

Pioneer house near the junction of US-177 and I-70 south of Manhattan.

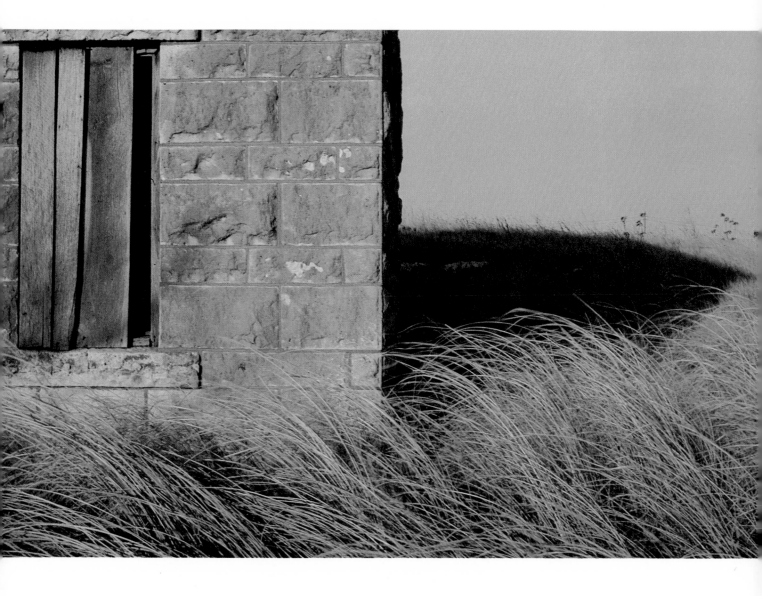

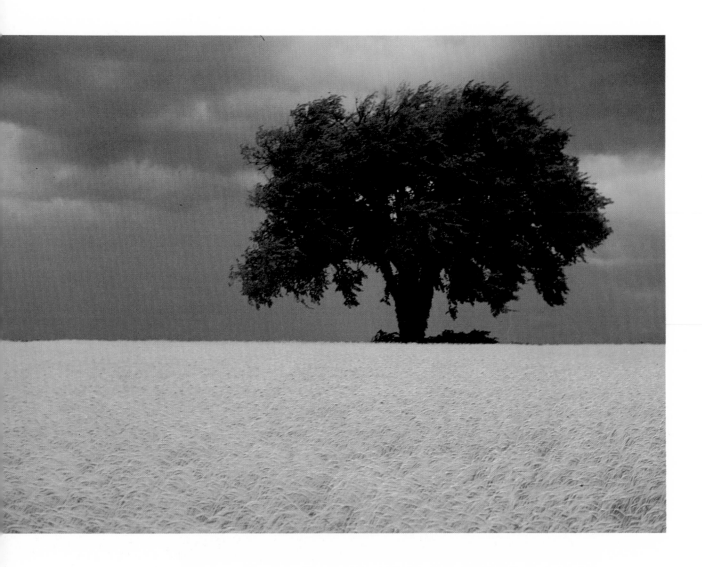

*F*og surrounds the Sedalia Community Church near
Manhattan.

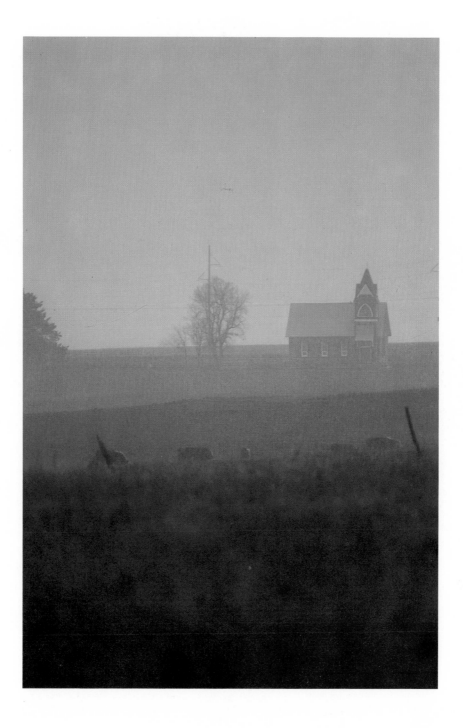

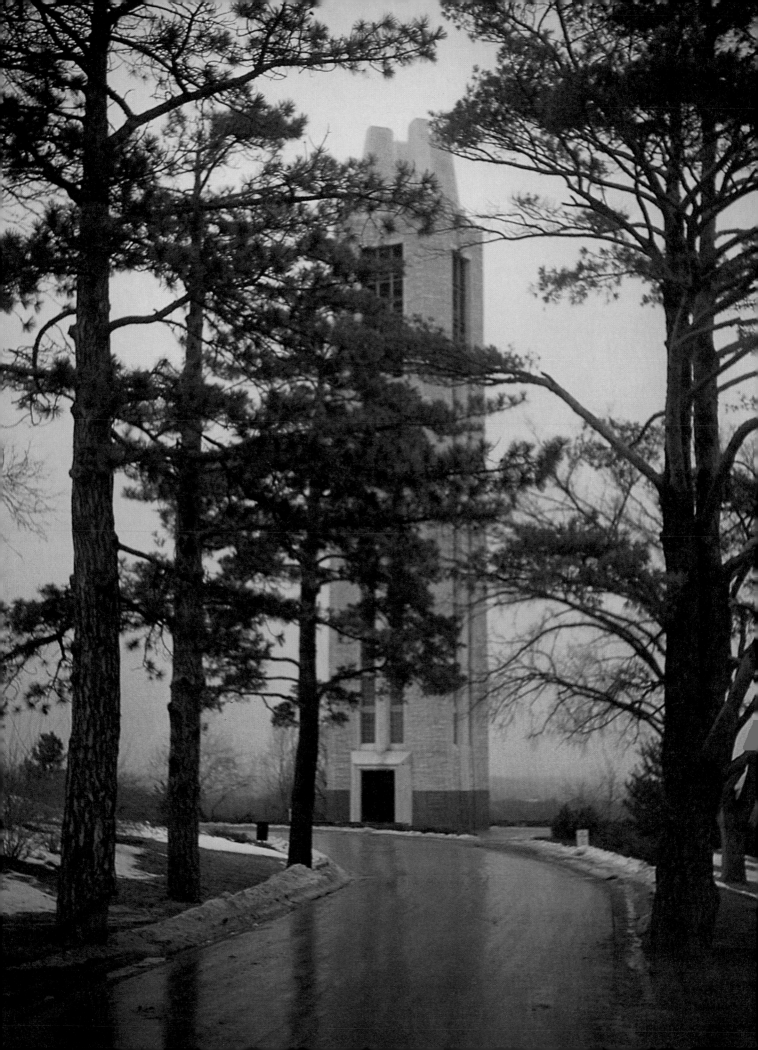

Campanile on the University of Kansas campus in Lawrence.

Kansas wildflower near Hugoton.

I-70 and I-35 cloverleaf in Salina.

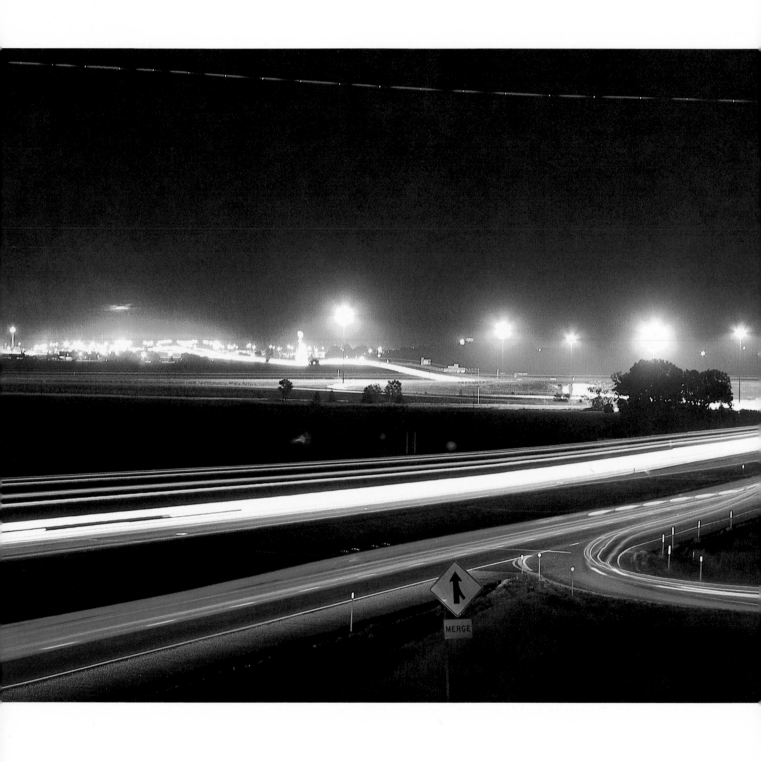

Rail is a major method of transportation of Kansas goods.

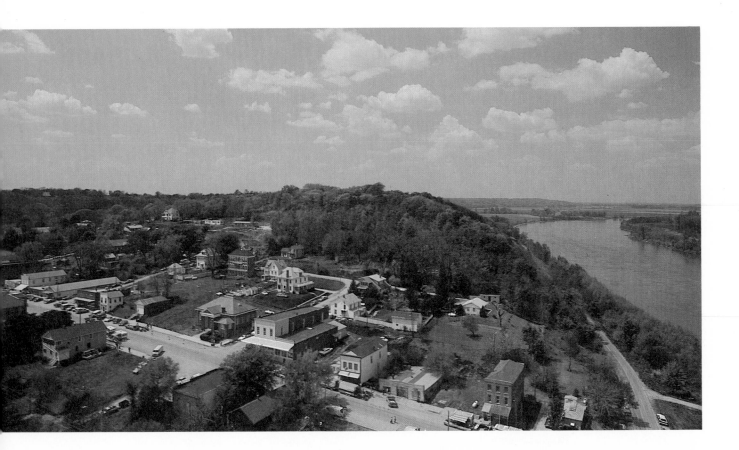

Wichita is the state's largest city and a world leader in aircraft production.

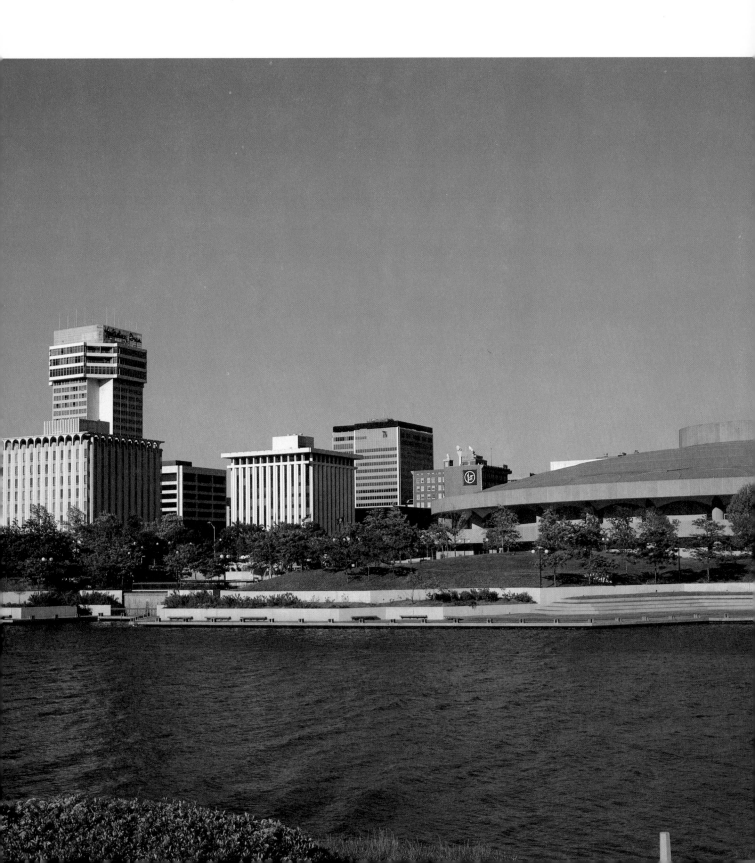

*A*nderson Hall on the Kansas State University campus in
Manhattan.

*K*ansas State Capitol.

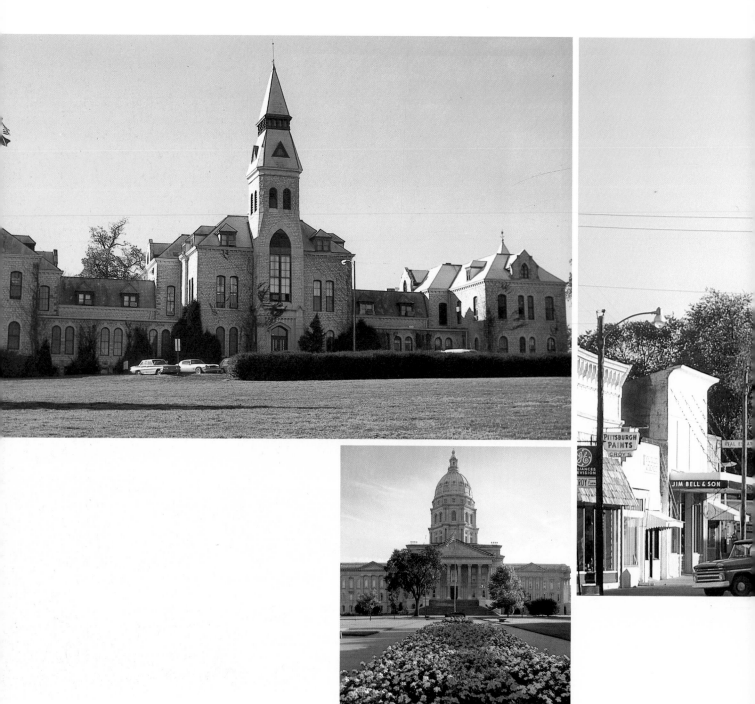

Chase County Courthouse in Cottonwood Falls.

Pages 106–7. Balloons lift off from the Statehouse grounds in Topeka.

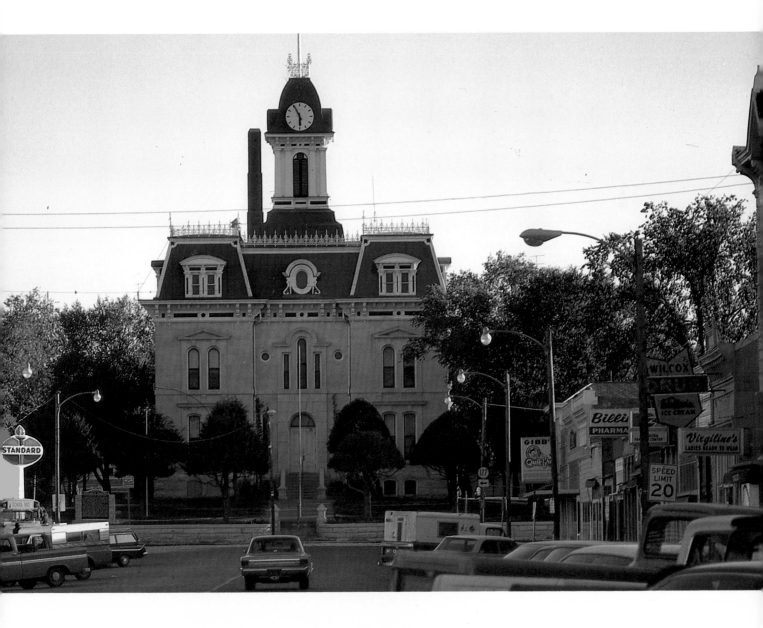

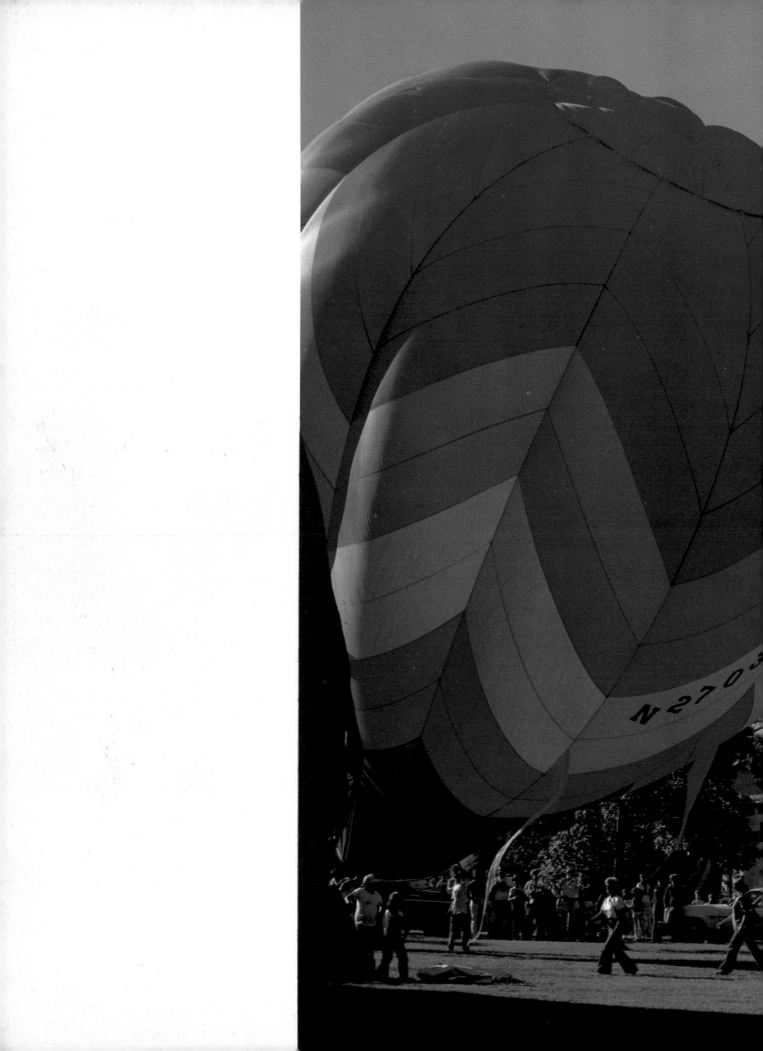

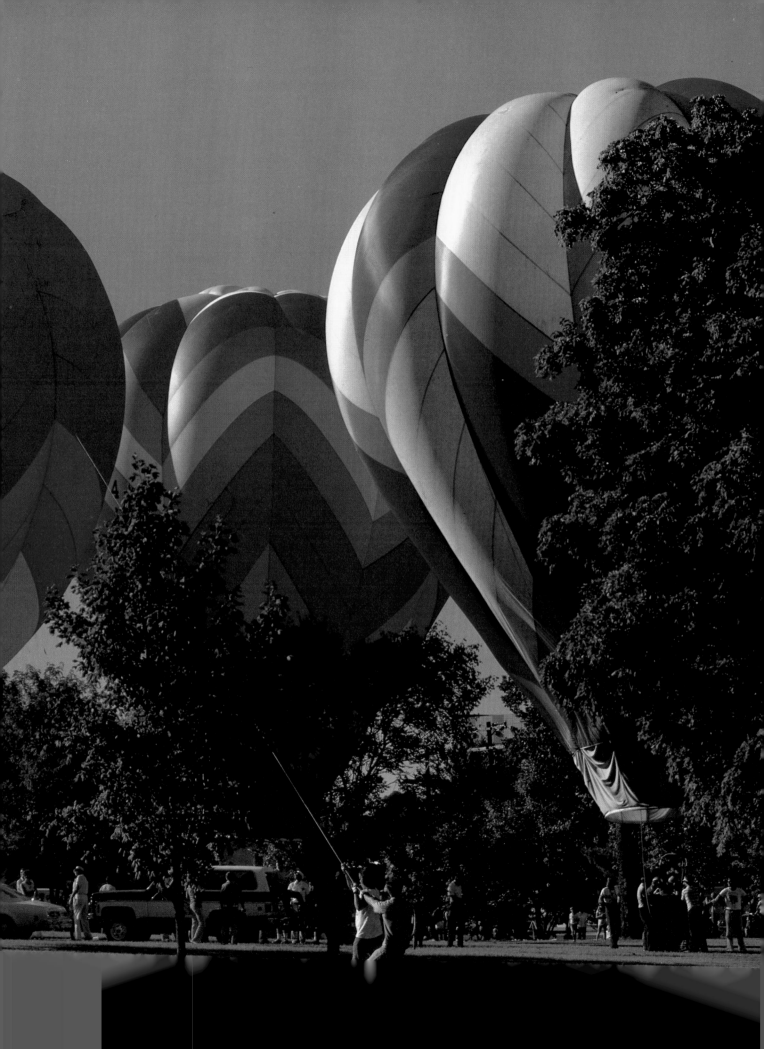

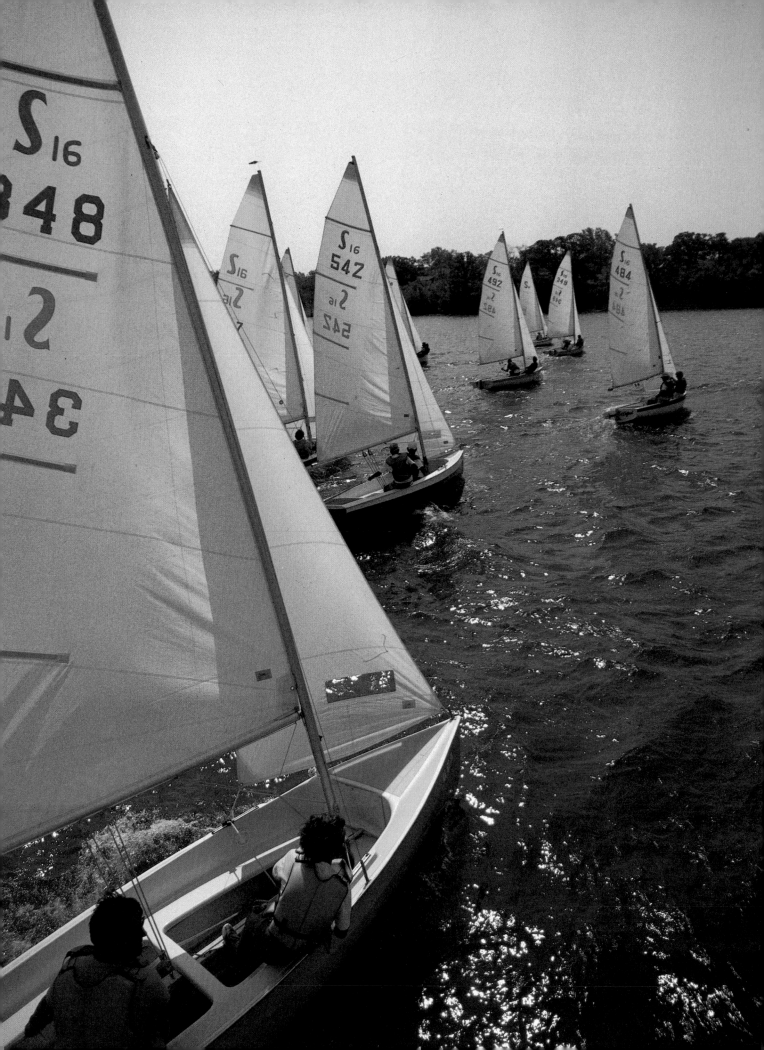

Sailing regatta on Lake Shawnee near Topeka.

Hang glider over Wilson Lake in Russell County.

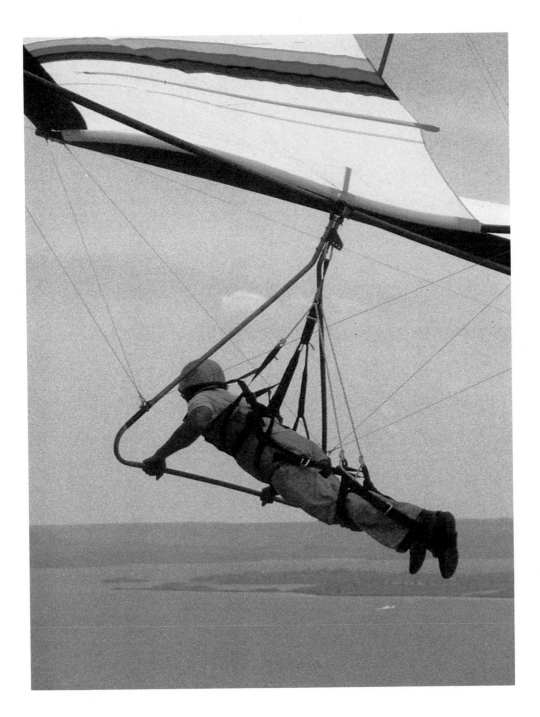

Skyline of Strawberry Hill, a Croatian community in Kansas City.

Kansas artist Stan Herd's Stagecoach Mural *on the First National Bank and Trust Company's building in Dodge City.*

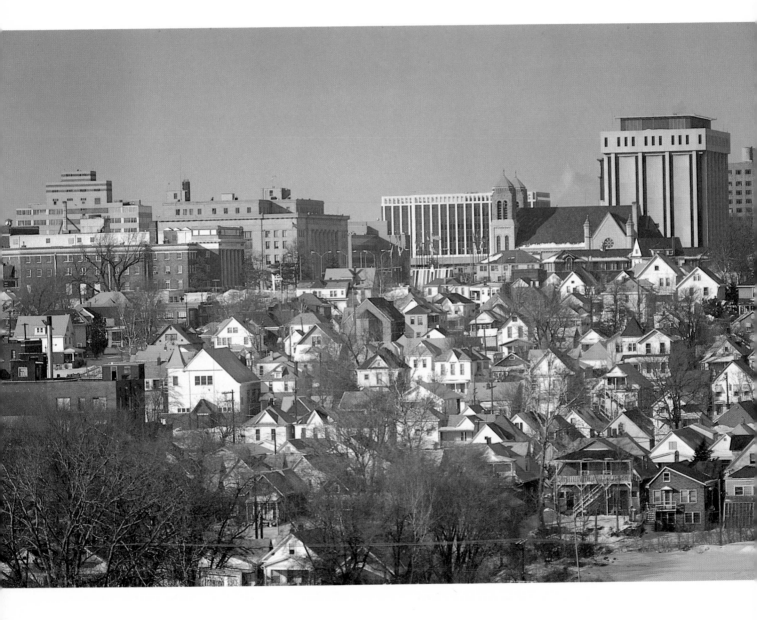

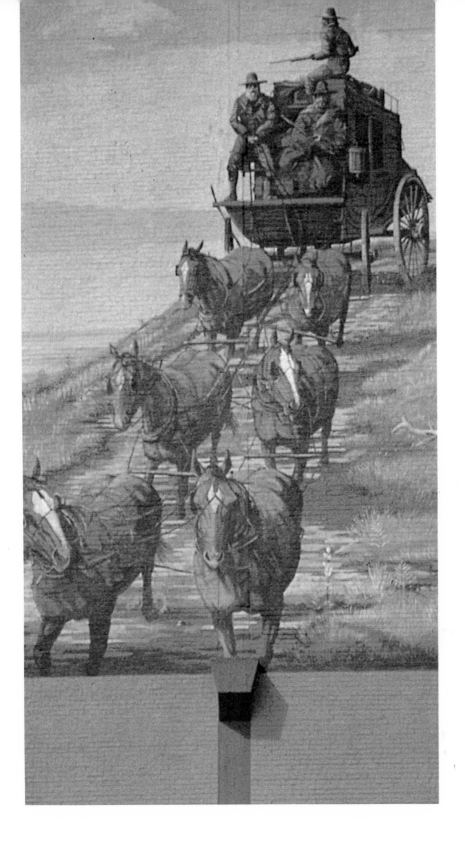

Historic Ward-Meade Home and Park in Topeka.

Hardesty House in the Boot Hill area of Dodge City.

*F*ort Scott, established in 1842, is a National Historic Site.

*F*ront Street at Boot Hill in Dodge City.

*R*ainbow at storm's end in Marion County.

*P*ages 116–17. Sunset near Eureka.

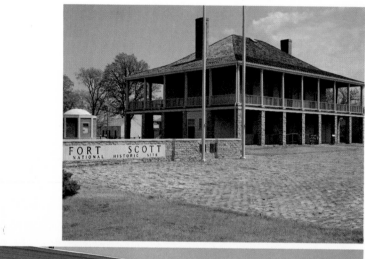

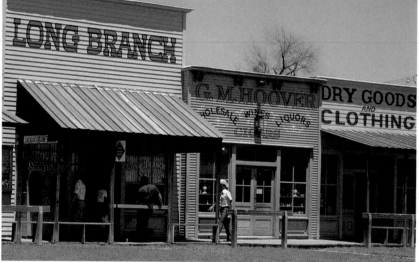

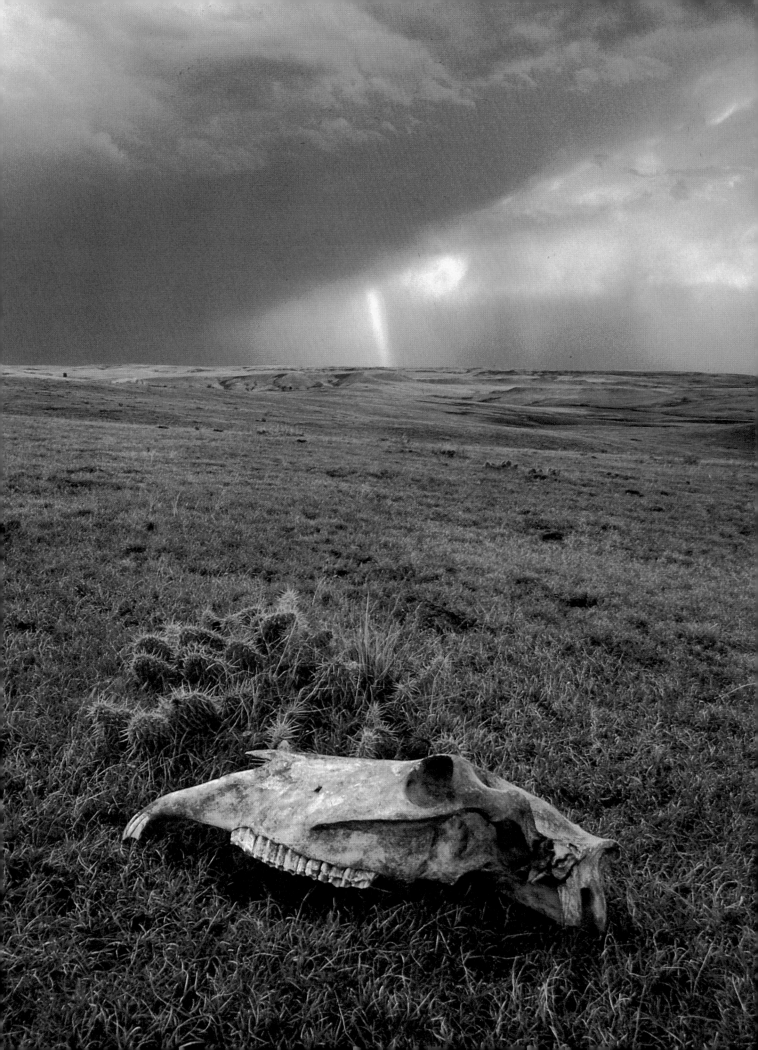

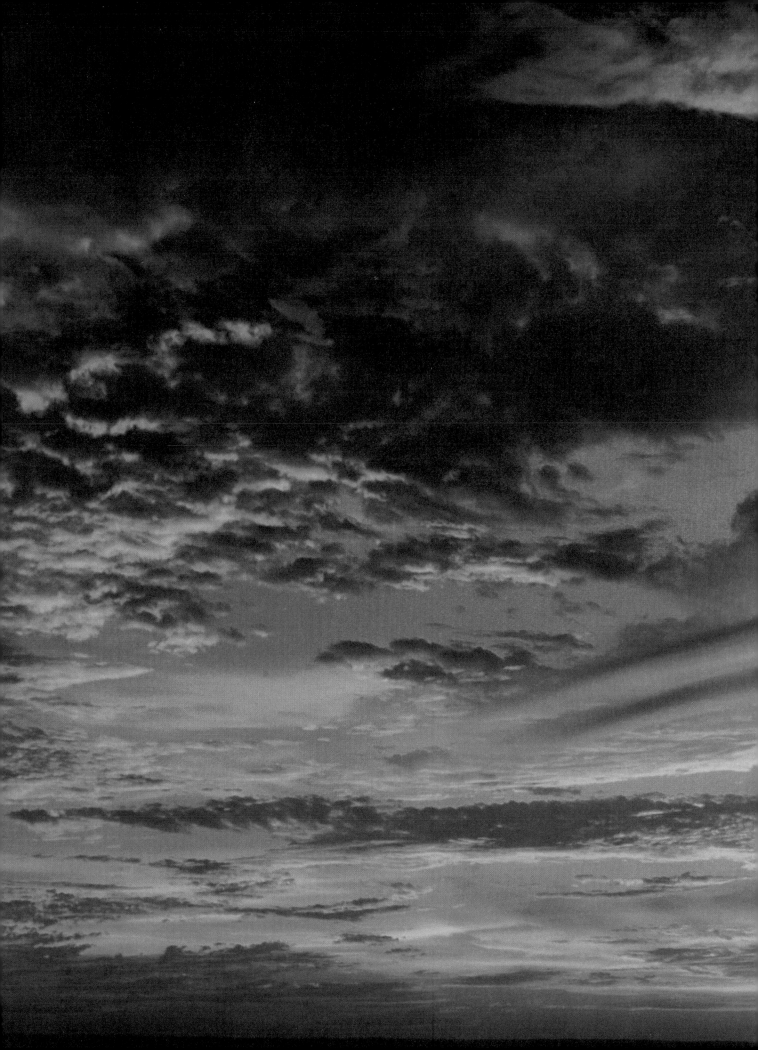

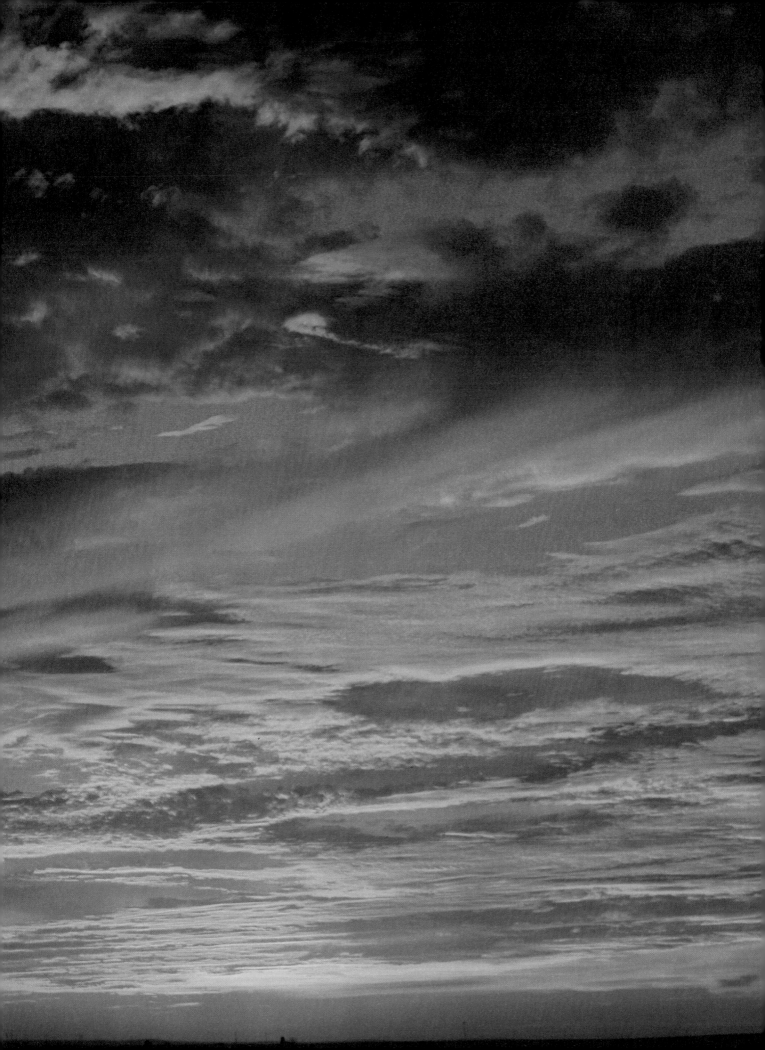

*E*lephant Rock near Oberlin in Decatur County.

*P*age 120. Garden of Eden in Lucas.

*P*age 121. Mushroom Rocks near Kanopolis Lake in Ellsworth County.

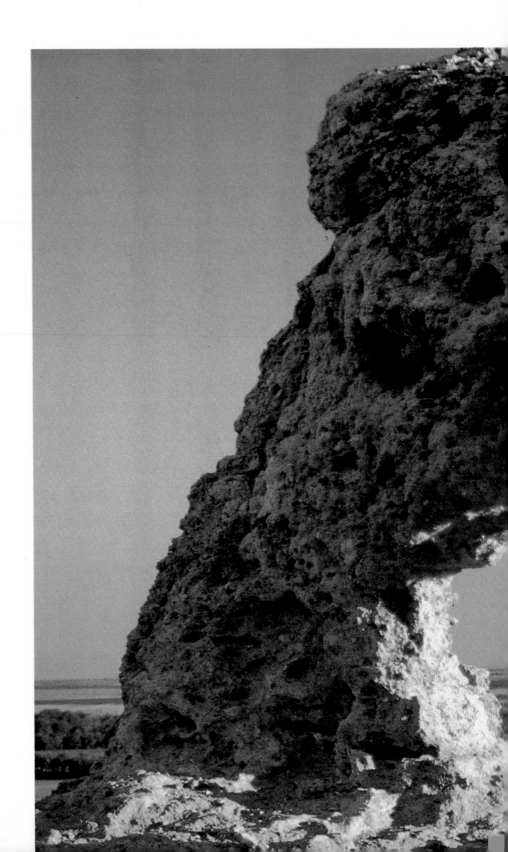

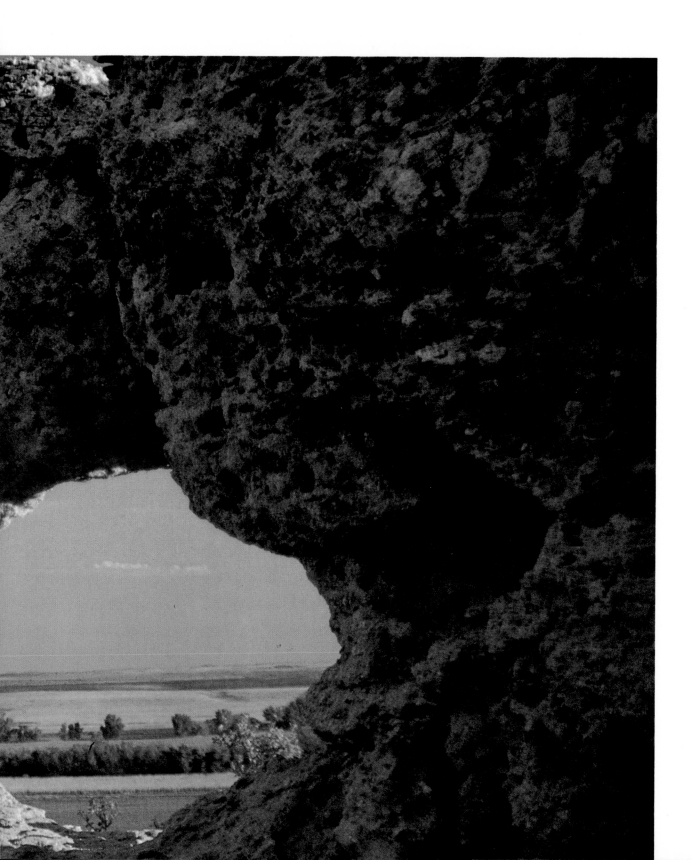

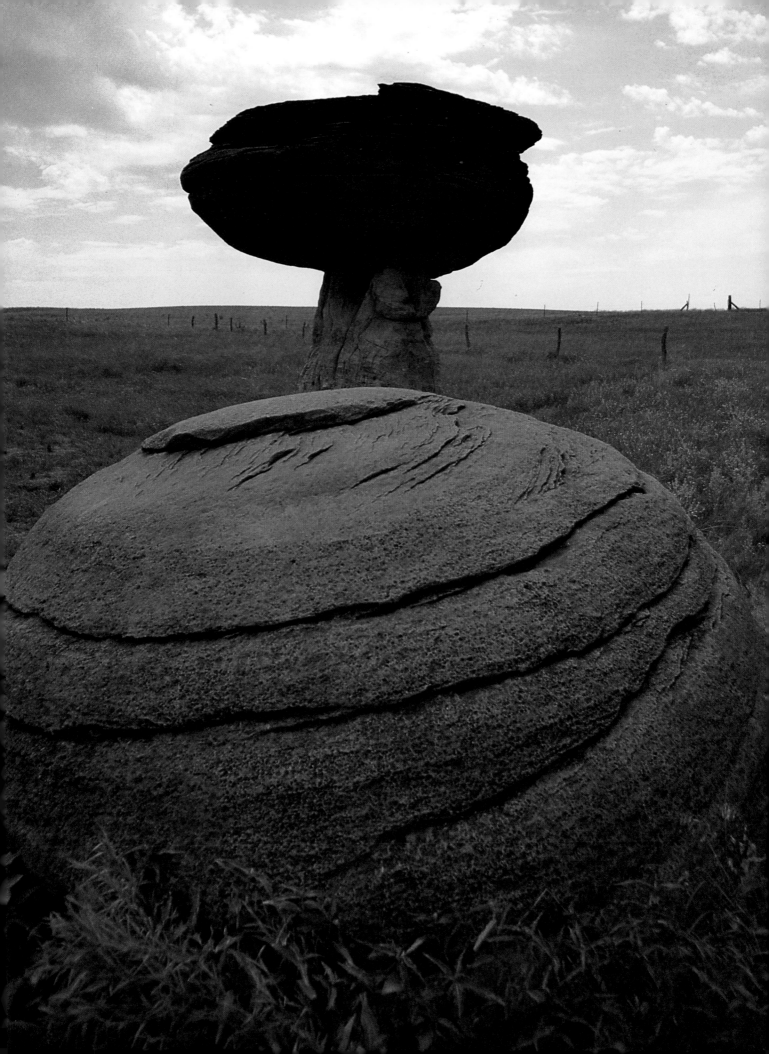

A butterfly alights on a marigold.

Mentzelia near Castle Rock in Gove County.

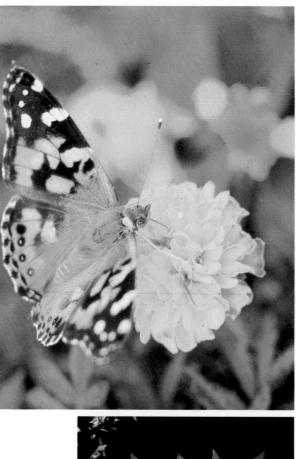

Arid countryside in Clark County.

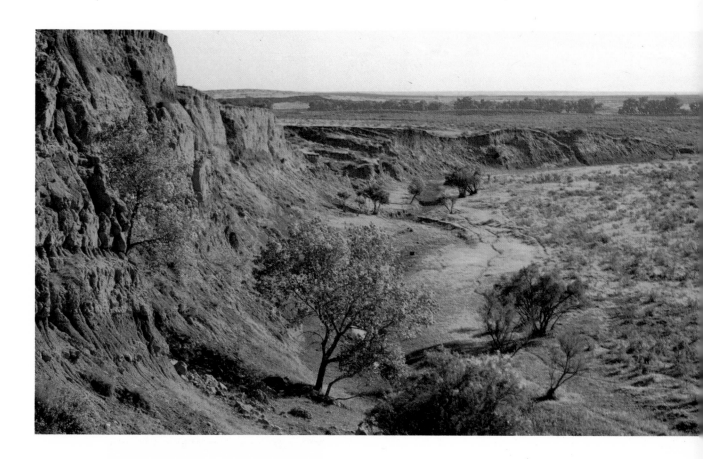

A depression in the earth near Dodge City is all that remains of Asa T. Soule's Eureka Canal which was built between 1884 and 1885.

Storm clouds approach Perry Reservoir near the Rock Creek area.

Pages 126–27. Sunset at Castle Rock south of Quinter in Gove County.

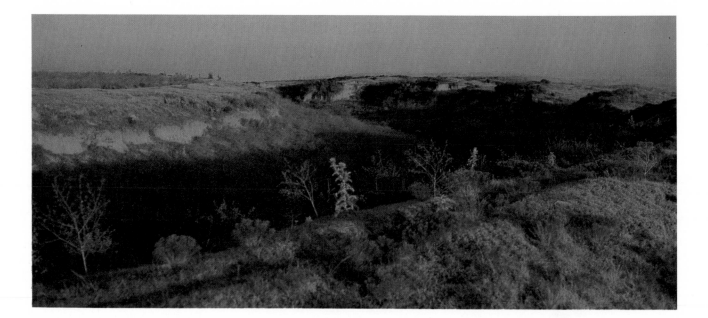

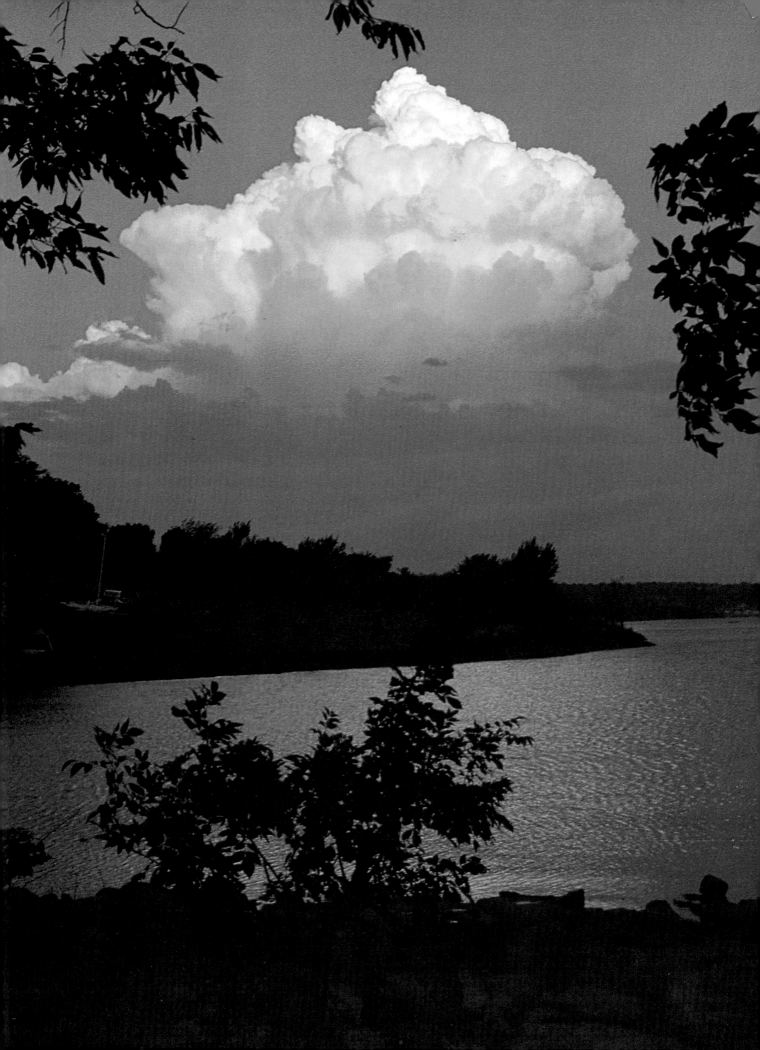

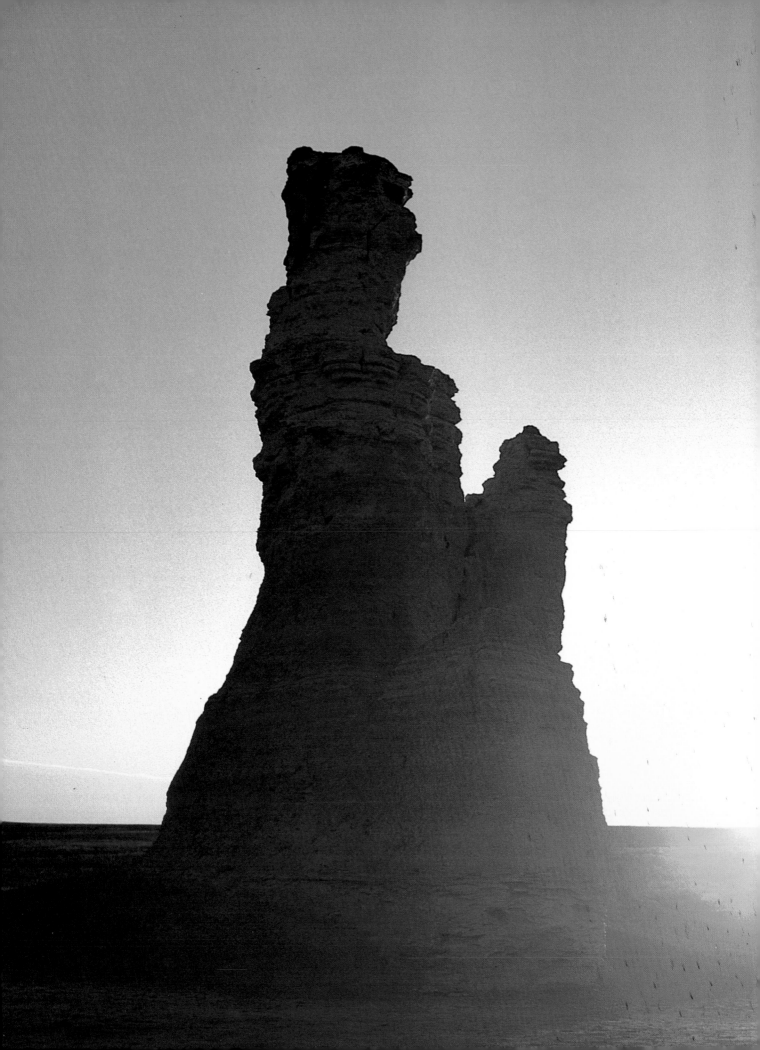

PHOTOGRAPHY CREDITS

Suzanne Burdick: page 84.

James Correll: pages 113, 114.

Dan Dancer: pages 1, 6, 40, 64, 80, 94, 96, 102, 115.

Phyllis Farrar De Vries: pages 32, 125.

Patricia D. Duncan: pages 28–29, 46, 54–55, 57, 70–71, 72–73, 90, 95, 105, 110.

Bruce Henderson: pages 103, 116–17.

Dick Herpich: pages 22–23, 44, 53, 58, 87, 88–89, 106–7.

Ken Houchin: pages 18–19, 38, 43, 68, 78 (top), 82.

Roy D. Hough: pages 79, 100–101.

Nancy Iddings: pages 85, 92.

Earl Iversen: pages 52, 62, 66–67.

Bern Ketchum: page 108.

Dave La Belle: pages 47, 51.

Don Lee: page 97.

Holly Miller: pages 36–37.

Bill Sheppard: pages 17, 62–63.

Pete Sousa: page 93.

Bill Stephens: page 104 (bottom).

Kent Stucky: pages 20, 39, 45, 49, 50, 74, 78 (bottom), 81, 82–83.

Rick Thorne: pages 2–3, 118–19, 121.

Jenny Thorns: page 109.

Betty Watson: page 26.

Ginny Weathers: pages 21, 24–25, 26–27, 42, 56, 59, 60–61, 69, 75, 76–77, 91, 99, 112, 122 (top), 122 (bottom), 126–27.

Ron Welch: page 114.

Tim Wenzl: page 124 (top).

Mark Wiens: pages 30–31, 33, 34–35, 41, 64–65, Jacket.

Ann Winter: page 48.

Stephen Zuk: page 101.